IMAGES
of America

LOST BUXTON

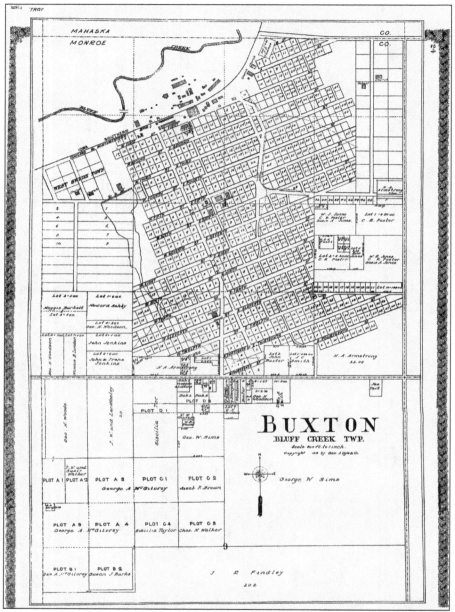

BUXTON, IOWA, PLOT MAP, 1919. "[In 1900, the Consolidation Coal Company] purchased 8,600 acres of Monroe County land and 1,600 of adjoining Mahaska County land for $275,000 . . . Ben C. Buxton . . . founded the town of Buxton, about twelve miles north of Albia . . . Here the company invested $6 million in buildings, mine equipment and coal rights." (Quote from *Monroe County News*, September 1, 1993; photograph courtesy of Michael W. Lemberger.)

ON THE COVER: THE MILLERS IN FRONT OF BUXTON HOME. "But it was so much, you know, so much you could say about Buxton. It could be a book within itself. A world within itself, you know, the culture of the people." (Quote by Dorothy Collier, African American resident, oral history, 1980; photograph courtesy John Jacobs.)

IMAGES
of America

LOST BUXTON

Rachelle Chase
Foreword by Leo E. Landis

ARCADIA
PUBLISHING

Published by Arcadia Publishing
Charleston, South Carolina

Library of Congress Control Number: 2016941007

For all general information, please contact Arcadia Publishing:
Telephone 843-853-2070
Fax 843-853-0044
E-mail sales@arcadiapublishing.com
For customer service and orders:
Toll-Free 1-888-313-2665

Visit us on the Internet at www.arcadiapublishing.com

For Dorothy Schwieder and the Buxton residents, whom I wish I could have met, and for Leigh Michaels and Michael Lemberger, who introduced me to Buxton. Without you all, there would be no book.

CONTENTS

FOREWORD

Among the most compelling Iowa stories is that of Buxton, a coal mining town largely in Monroe County, with a peak population of between 5,000 and 6,000 residents in the era from 1900 to the 1920s. The community of miners would not be surprising except for the fact that the majority were African American. This integrated community defied racial norms in many ways as African Americans served in leadership roles and held professional positions in the community.

In his 1903 work *The Soul of Black Folks*, W.E.B. DuBois wrote, "The problem of the Twentieth Century is the problem of the color-line." Organized by Ben C. Buxton of the Consolidation Coal Company in 1900, the color line may not have been fully broken in Buxton, but it was certainly fractured. The company actively recruited African Americans to work in the mines, as well as Swedes, Slovaks, and other nationalities.

As an Iowa historian, I know the essays and books compiled to describe the community's history, including works by Dorothy Schwieder, David Rye, David Gradwohl, and Nancy Osborn Johnsen. Rachelle Chase has done a masterful job with this volume, *Lost Buxton*, creating a much needed photographic history on the community. While photographs cannot tell the entire story of the people of Buxton, it shows the dignity of their work and home life. We cannot know the full breadth of their experiences, but this work is a valuable photographic document.

Admittedly, the people of Buxton faced tragedy and struggled at times. Mining was dangerous work, and men were injured or killed on the job. However, the social networks provided outlets for the people of Buxton to make better lives for themselves.

When coal mining was at its peak, Monroe County's population topped 25,000; in 2010, the county population was less than 8,000. Buxton offers an example of survival and collapse for the rural Midwest. It is a marvelous example of an integrated community and demonstrates that when all are given equal opportunity and equal treatment, a community thrives. Consider these lessons as you examine this work.

—Leo Landis
State Curator, State Historical Society of Iowa

ACKNOWLEDGMENTS

Special thanks to Leigh Michaels for handing me file folders of notes and repeatedly saying, "You should do a book on Buxton!" for the past eight years; Becki Plunkett, Shari Stelling, Bruce Kreuger, Tony Jahn, and Leo Landis at the State Historical Society of Iowa–Des Moines and Doris O'Brien and Rosalie Mullinix at the Monroe County Historical Society & Museum for continuing to pick up the phone when they saw my number and helping me with research; the late Michael W. Lemberger, John Jacobs, Mary Bennett, and Charles Scott at the State Historical Society of Iowa–Iowa City, as well as Laura Sullivan, Brad Kuennen, and Rachel Seale at Iowa State University and Felicite Wolfe and Krystal Gladden at the African American Museum of Iowa for answering my desperate pleas for "just one more" Buxton image; Dorothy Schwieder, Elmer Schwieder, Joseph Hraba, and the Buxton residents for the oral histories used in this book; Jim Keegel and LeeAnn Dickey for preserving Buxton and keeping it alive; Caitrin Cunningham, Ashley Harris, and the Arcadia Publishing folks behind the scenes who have been fantastic to work with; and, as always, my family—Bob, Mattie, Monica, and Anthony—for their love and support of all that I do.

For the sake of space, the sources of the photographs used in this book have been abbreviated as follows: State Historical Society of Iowa–Des Moines (SHSI-DSM), State Historical Society of Iowa–Iowa City (SHSI-IC), Monroe County Historical Society & Museum (MCHS&M), the African American Museum of Iowa (AAMI), and Iowa State University (ISU). The Buxton resident oral histories, both audio and transcripts, are part of a collection at SHSI-DSM.

The quotes used in this book may have grammatical errors or misspellings—this is intentional, as every effort has been made to capture the statements exactly as they were spoken or written.

For more information on Rachelle Chase, visit www.RachelleChase.com.

INTRODUCTION

If they thought we'd be talking about Buxton 60 years later, nothing was ever
mentioned about that because I don't think it ever entered anybody's head that
there would be such a commotion made over the town like there is.

—Harvey Lewis, Caucasian resident, oral history, 1980

Harvey Lewis may be right. By all accounts, Buxton was simply another business venture for the Consolidation Coal Company. When the coal played out in the Muchakinock mines in Mahaska County, Consolidation moved the coal mining camp to Buxton in 1900, and just as the company had done in Muchakinock, it recruited African Americans, as well as Europeans, to work the Buxton mines. But by the early 1920s, the Buxton mines, just like those in Muchakinock, played out, thereby ending Buxton.

So why is such a "commotion" still being made over Buxton 37 years after Harvey Lewis's statement and nearly 100 years after Buxton's demise? Why did Buxton, throughout its existence, frequently appear in Iowa newspapers, such as the *Albia Republican, Eddyville Tribune, Oskaloosa Herald*, the *Ottumwa Courier*, the *Evenings Time-Republican*, and the *Iowa State Bystander*, the latter being the largest African American newspaper in Iowa, which issued souvenir editions featuring Buxton in 1903, 1905, and 1907? And after it turned into a ghost town, why has Buxton continued to appear in books, on television, and in publications and newspapers, including the *Chicago Tribune*?

The answer: Because Buxton was different from other coal mining towns of the time, both in terms of the residents and the town itself.

By the time Buxton was five years old, approximately 55 percent of its nearly 5,000 residents were African American. Not only did Ben C. Buxton, who took over the role of general superintendent of Consolidation from his father in 1896, recruit African Americans, he went out of his way to insure they, like their white counterparts, were treated fairly. The black miners received the same wages as white miners. Company housing was awarded on a first come, first served basis, which resulted in blacks and whites being neighbors. Black and white children were in the same classrooms and were taught by black and white teachers.

While African Americans in Iowa and throughout the country were relegated to separate sections of towns and barred from businesses, African Americans in Buxton were free to shop, walk, eat, sit, attend events, and live anywhere they wanted, without restrictions. While African Americans elsewhere were dealing with lynchings and Ku Klux Klan activities, African American residents in Buxton felt safe, some admitting to sleeping with their doors open or unlocked. While African Americans elsewhere struggled to find work beyond menial or domestic help jobs, Buxton had African American professionals and business owners, in addition to miners.

African American professionals included doctors, lawyers, a dentist, pharmacists, constables, teachers, commercial and rental property owners, an insurance agent, company store clerks and at least one manager, a bank manager, a cigar maker, a postmaster, a mine engineer, two justices of the peace, barbers, a tailor, and many entrepreneurs.

Black-owned businesses included hotels, restaurants, grocery stores, confectioneries, a bakery, drugstores, pool halls, dance halls, a music store, a photography and printing business, a meat market or two, millinery shops, and at least four newspapers. The *Iowa State Bystander* reported that there was "a saloon and billiards hall" in Coopertown; however, there were numerous shacks that residents also referred to as saloons. Additionally, at one time, there were at least eight black churches.

Socially speaking, there were African American lodges and secret societies, such as the Masons, Odd Fellows, Elks, Knights of Tabor, and Knights of Pythias for men and the True Reformers for women. Other clubs for women included the Sweet Magnolias Club, the elite Silver Leaf Club, the Ladies Industrial Club, Booker T. Washington Literary Club, and lodges, such as the Household of Ruth and the Knights and Daughters of the Tabernacle. More than 40 women's organizations for black women existed in Buxton during the early 1900s. There were two black bands that traveled throughout the state, with the Buxton Cornet Band, a 36-piece group, being reported as "the best colored band in the state" by the *Oskaloosa Saturday Herald* in 1905; a black basketball and football team at the YMCA; and the Buxton Wonders, originally a black baseball team, though there were white players and a white manager in later years.

Then there was the town of Buxton itself. Most mining camps were designed to be temporary, with cheaply constructed, one-story, four-room houses. Little thought was given to the town layout or the resident's recreational needs. Besides housing, the only other amenities usually provided were a grade school, union hall, tavern, and company store. In contrast, Buxton seemed to have been designed with a level of permanence in mind. According to the September 18, 1903, Buxton Souvenir edition of the *Iowa State Bystander*, Ben Buxton "designed and superintended the laying out of the town, the plans and construction of the buildings . . . the water supply, the drainage and all the many interesting details." Those structures included one-and-a-half-story houses, which were maintained by the company, and had fenced yards big enough for gardens; a two-story company store, complete with elevators, which was later replaced with a blocks-long single-story brick building after the original store burned down—both also had basements; two-story schoolhouses; a high school; a three-story YMCA building that cost $20,000 to construct and was reputedly built for use by African Americans, though all races went to the movie theater on the second floor and used the meeting rooms; a small YMCA with a swimming pool; plus parks, ballparks, a skating rink, and tennis courts.

Why did Ben C. Buxton do this, make Buxton a town where people would enjoy living and outsiders would want to visit or shop? Why did he promote equality and a sense of community? Why did he do any of this when he could have gotten away with doing none?

Residents thought highly of Ben Buxton, and some, like African American resident Charles Taylor, attributed it to his altruistic nature. "He really had the people at heart . . . He wanted them to have the best of everything. He wanted them to have a real good living. He wanted them to live good." Historians, such as Dorothy Schwieder, Joseph Hraba, and Elmer Schwieder in their 2003 book *Buxton: A Black Utopia in the Heartland*, take a more pragmatic approach, suggesting that the Buxtons may have been influenced by the welfare capitalism movement under way at that time. Welfare capitalism, which sought to create loyal and productive workers—who would not strike—by providing services beyond those considered a necessity or required by law, was being employed by the railroad industry at the time Buxton was established. Perhaps Ben Buxton had that in mind when he established Buxton. But no one really knows, as there is no written record explaining why Buxton was set up the way it was.

Was Buxton really as great as all this, as "perfect" as it sounded?

In 1980, a proposal was submitted to the Heritage Conservation and Recreation Service (Department of the Interior) for funding a study of Buxton to obtain answers to these questions

and more. Four months later, the funding was approved, with the termination date set for 1982. The study was conducted in two parts: Iowa State University professor David Gradwohl and Nancy Osborn conducted an archeological excavation of the Buxton site and professors Dorothy Schwieder, Elmer Schwieder, and Joseph Hraba conducted interviews with former residents. Based on the interviews of more than 80 former residents, Buxton—according to African American residents—did appear to be a utopia of sorts. For its time.

Which means it was not perfect.

Residents' opinions varied on how socially integrated Buxton truly was, with some echoing Caucasian resident Earl Smith's comment, "I played with colored kids the same as I did white ones" and others qualifying that by stating they only played together at school, while still others stated they went to each other's houses. Similarly, some of the men stated they only worked together, while others stated they had black or white friends and socialized—such as gambled or had drinks—together.

Signs of racism surfaced during the interviews. Some white residents repeatedly used racial slurs when referring to African Americans while others attributed the success of some prominent African Americans to them not being "full blacks." Conversely, a black resident stated that, due to his grandparents' experiences as slaves, they preached not to trust white people and did not associate with them.

While most residents agreed that alcohol and gambling, readily available in certain suburbs of Buxton, were the cause of fights and the majority of murders (the other cause being domestic disputes), they disagreed on frequency, with some saying "rarely" and others saying "every payday."

But countering these imperfections and contributing to the sentiment of Buxton as utopia—for its time—was this: Nearly all residents, black and white, stated that: (1) segregation in Buxton was by choice, with no one being prevented from going anywhere they desired, and (2) crime was not racially motivated.

Why did people who were used to living segregated lives amidst racial tension before Buxton seemingly get along? Maybe it is as former resident Bessie Lewis said, that people who could not adjust did not stay in Buxton long. Or maybe former resident Charles Lenger got it right when he said, "Everybody seem like they had a good life because they had money . . . that's why they got along." Or maybe it is both—or neither.

All the people who may have had the answers to all of these whys, including the former residents interviewed in the study and whose words appear on these pages, are no longer alive. At the time of the interviews, the former residents were in their 70s, 80s, and 90s, remembering back 60 or more years to recall experiences in Buxton. While facts have been verified when possible, many of the details about Buxton that remain are sometimes contradictory and many photographs have little to no information recorded.

Thus, *Lost Buxton* is not a scholarly treatise. Instead, let it pique your interest by providing a glimpse of a town that no longer exists through the words of people who are long gone.

One

BUXTON IS BORN

In 1881, the Chicago & North Western Railroad bought the Consolidation Coal Company and its mines at Muchakinock in Mahaska County from brothers H.W. and W.A McNeill for $500,000. That same year, the company implemented a change to the miners' pay method, causing the miners to strike. To keep things running, company recruiters traveled south—namely to Virginia—to convince African American workers to come work in the Muchakinock mines.

For the struggling sharecroppers or unemployed men, the promise of relocation and $20 per week as they learned a new trade may have been convincing enough. The recruitment efforts were successful. From 1881 to 1885, seventy percent of the men—i.e., 350 of the 500—hired were African American.

The town continued to grow. By 1895, according to the Iowa Census, 3,844 people lived in Muchakinock, though it appears that African Americans were no longer the majority.

By 1898, there were a number of businesses, such as the company store, a couple of restaurants, saloons, barbershops, and churches, plus grade schools, pool rooms, a meat shop, a band, a baseball team, and a black newspaper called the *Negro Solicitor*. But by 1900, the company's mines had played out.

That spelled the end for "Muchy"—and the beginning of Buxton. According to Buxton resident Herman Brooks, "The people that moved from Muchy, everybody didn't move all at one time, you see, because they couldn't build the houses fast enough. They'd have to get so many houses built, see. And then you would get orders to move." In November 1900, the *Monroe County News* reported that 100 new homes had been built and "there will be a great exodus from Muchakinock, and sixty families will bid farewell to the homes they have known and loved so long."

As people settled in Buxton, suburbs appeared. Some—Coopertown, Gainestown, Hayes Town, and Wells Town or Wells Hill—were named after men who owned the land or businesses. Others—East Swede Town and West Swede Town—took after the ethnicity of people who lived there. And the origins of some—Sharp End and Gobblers Knob—were a mystery.

From 1900 to around 1914, Buxton continued to grow. The April 29, 1905, edition of the *Oskaloosa Saturday Herald* reported, "Mine Inspector John Verner in speaking of the inexhaustible supply of coal in Monroe County, said the life of the mining town of Buxton would be at least 50 years and perhaps more."

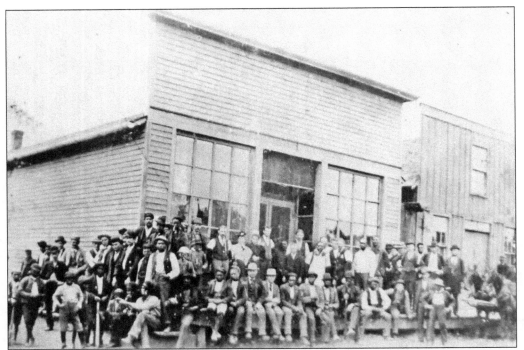

MINERS, CLERKS, AND RESIDENTS AT THE MUCHAKINOCK COMPANY STORE, C. 1890S. "The man went down there [Virginia] . . . and gathered up all them young boys and young men and brought 'em out here . . . My father couldn't read nor write . . . All he knew was to work on a farm . . . He thought he was comin' to a gold mine. Come to find out, he was comin' to a coal mine." (Quote by Mattie Murray, African American resident, oral history, 1981; photograph courtesy SHSI-IC.)

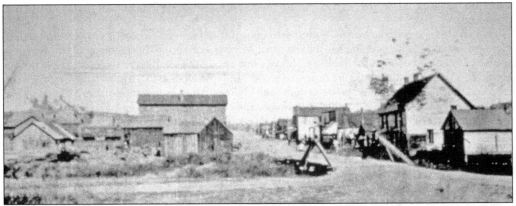

TOWN OF MUCHAKINOCK. "Muchy, in itself, wasn't too big but was a lot of farmland around . . . Mucha, see, you didn't have to go very far to buy chickens and all like that, you know, and you just had to go a little piece because it was surrounded with big farms." (Quote by Herman Brooks, African American resident, oral history, 1981; photograph courtesy ISU.)

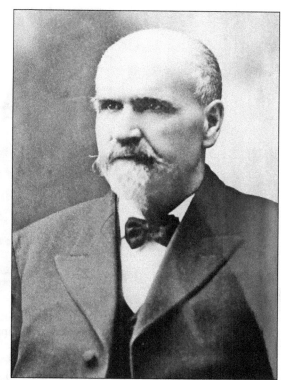

JOHN E. BUXTON (RIGHT) AND BEN C. BUXTON (BELOW). "He [Ben] was superintendent of the Consolidation Coal Company. See, over in Muchakinock, his dad was the superintendent and then when they moved it to Buxton, why, he turned it over to his son. See, Ben was a young man. Hell, he was only 25 years old when he come to Buxton." (Quote by Harvey Lewis, Caucasian resident, oral history, 1980; both, photograph courtesy of a private collection.)

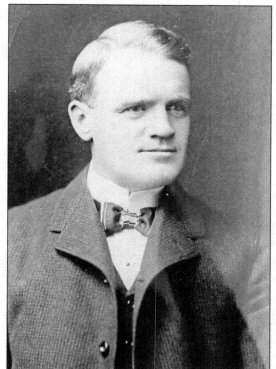

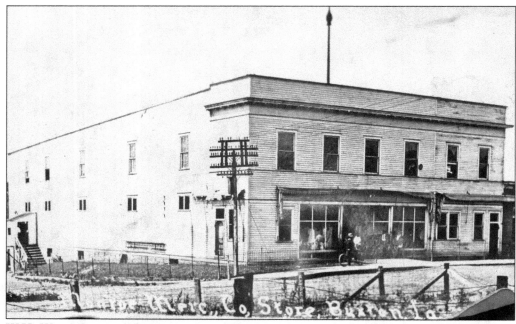

W.H. Wells Company Store, c. 1901. "The company store had everything you could imagine . . . they had a hat store in there, they had a funeral store . . . When you want to go up in the clothing part, you get on an elevator and it takes you up in the clothing . . . and everything. Hardware and all, that would be upstairs." (Quote by Susie Robinson, African American resident, oral history, 1981; photograph courtesy Michael W. Lemberger.)

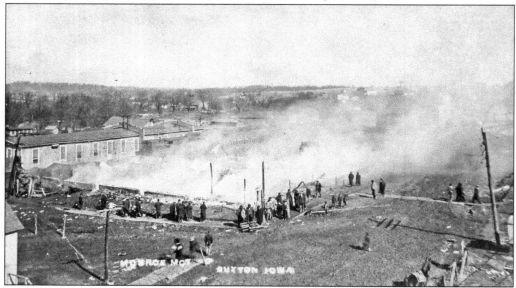

Company Store Fire, c. 1911. "Our house was struck by lightning and . . . mama said . . . this is a fire . . . And they hollered fire all over the camp . . . and the buckets was from the house, clear way around the block. They just kept them going . . . that's the way they put the fire out." (Quote by Dorothy Collier, African American resident, oral history, 1980; photograph courtesy John Jacobs.)

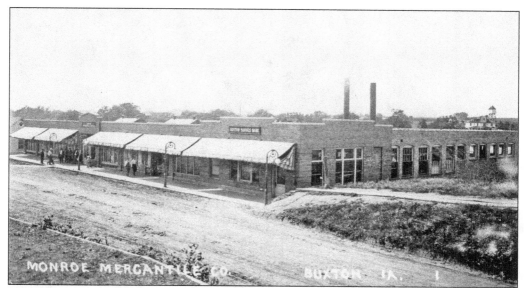

MONROE MERCANTILE COMPANY STORE, C. 1911. "You could buy anything in that company store from a diaper to a coffin. The company had its own morticians and own mortuary. They had a shoe department, shoe repair department, furniture, hardware, groceries, cooking ware, clothing, and yard goods. The company store had a bank in it, the company office, a soda fountain where they served lunches." (Quote by Carl Kietzman, Caucasian resident, oral history, 1981; photograph courtesy SHSI-DSM.)

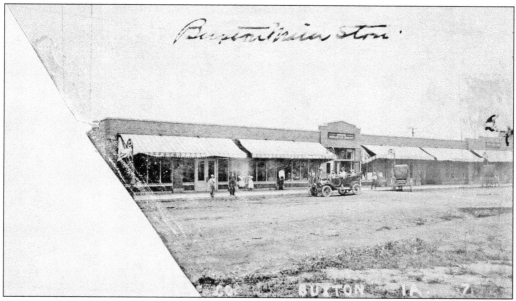

COMPANY STORE, ALSO KNOWN AS MONROE MERCANTILE COMPANY. "Some of the other coal mines in the country . . . the prices were awful high and the miners were told you either buy here [company store] or you don't work, you know. They strong-armed them into buying. That was common in coal mine camps all over the southern Iowa but I've never heard of anything like that here [Buxton]." (Quote by Harvey Lewis, Caucasian resident, oral history, 1980; photograph courtesy John Jacobs.)

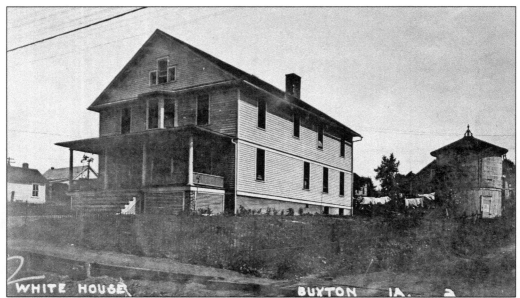

WHITE HOUSE

BUXTON IA.

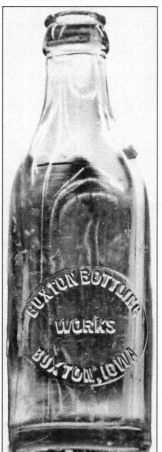

WHITE HOUSE HOTEL. This view is looking southeast from First Street. "It [White House Hotel] was right across from the company store, and these traveling men would come in selling groceries and things. They'd stay at that hotel." (Quote by Earl Smith, Caucasian resident, oral history, 1981.) "That wasn't a hotel, it was a rooming house." (Quote by Elmer Buford, African American resident, oral history, 1980; photograph courtesy SHSI-DSM.)

BOTTLE FROM BUXTON BOTTLING WORKS. "I had a pop factory by the depot, across the railroad tracks a little ways . . . I bought it from the Monroe Mercantile Company, the company store." (Quote by Adolph Larson, Caucasian resident, oral history, 1981; bottle courtesy MCHS&M; photograph courtesy Michael W. Lemberger.)

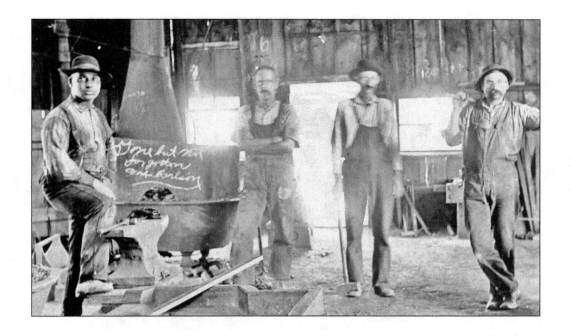

BLACKSMITH SHOP, C. 1905. "This was the company blacksmith shop behind the store, behind the big company store. This was right behind the store and that's where the company, well, they fixed all the stuff and welded it and made it." (Quote by Herman Brooks, African American resident, oral history, 1981; both, photograph courtesy SHSI-DSM.)

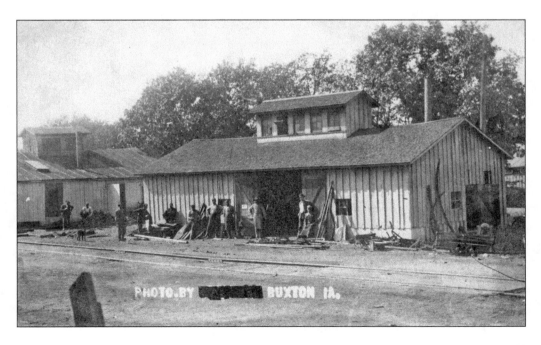

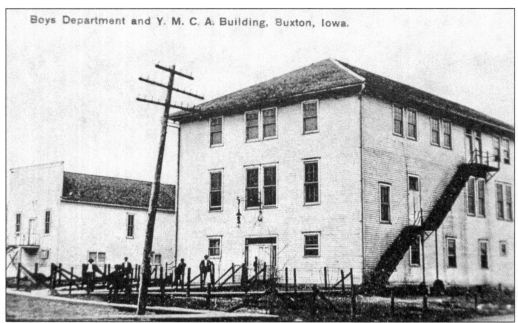

Boys Department and Y. M. C. A. Building, Buxton, Iowa.

Boy's YMCA and YMCA, c. 1907. "The first floor will be devoted to the association rooms proper, secretary's office, reading room, game room, library, writing room, kitchen, class rooms, gymnasium and large bath department. The second floor will contain a large assembly hall . . . The third floor will be devoted to lodge purposes . . . The building will be the first Y.M.C.A. structure of its kind in the world, devoted to . . . and under the management of colored men." (Quote from *Oskaloosa Daily Herald*, November 24, 1903; photograph courtesy SHSI-DSM.)

Corner of Main and First Streets. Looking east on First Street around 1912, one can see the telegraph office and W.H. Wells Company Store at middle left and the YMCA at right. "The company took care of their property. 'Course they had warehouses down there . . . had a warehouse for the furniture and hardware. Another warehouse for lumber, fencing materials, glass." (Quote by Carl Kietzman, Caucasian resident, oral history, 1981; photograph courtesy Michael W. Lemberger.)

BUXTON SCHOOLHOUSE.
"The schools took the name of the streets, if we may call them streets, on which they were located, or the section of town. Thus we had a First Street School, an Eleventh Street School, and a Swede Town School. They were two-story buildings of four rooms, each thus employing twelve teachers." (Quote by Minnie B. London, African American resident, memoir *As I Remember*; photograph courtesy SHSI-DSM.)

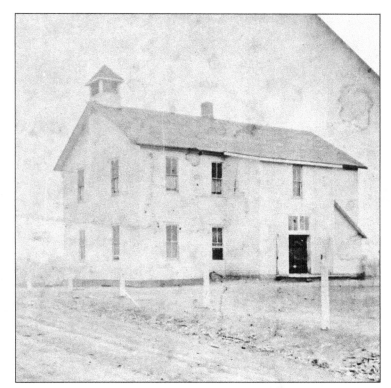

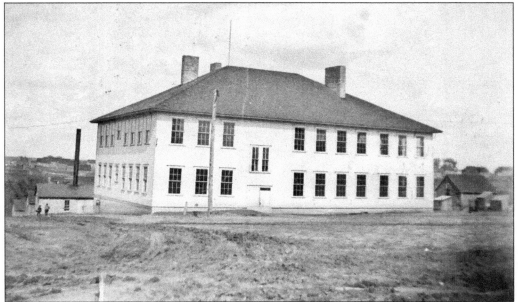

BUXTON HIGH SCHOOL, C. 1907. "The most spectacular fire ever seen in Monroe county occurred at this place Sunday evening . . . The fire was caused by the testing out of the new heating apparatus installed in the building . . . The loss of the building will amount to between ten and twelve thousand dollars." (Quote from *Oskaloosa Thursday Herald*, October 10, 1907; photograph courtesy John Jacobs.)

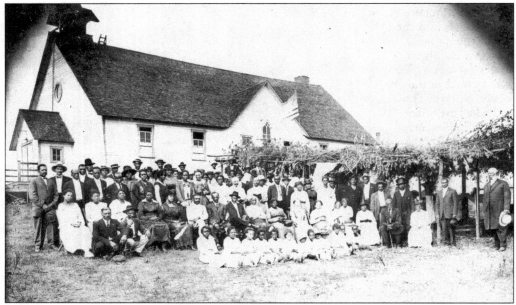

ST. JOHN'S AME CHURCH. "We'd have church on Sunday, Sunday school church, and then we used to have singers come, jubilee singers, come and give programs like that and we'd pay to go to that and then we used to give programs . . . that was most of our entertainment was from the church." (Quote by Gertrude Stokes, African American resident, oral history, 1981; photograph courtesy AAMI.)

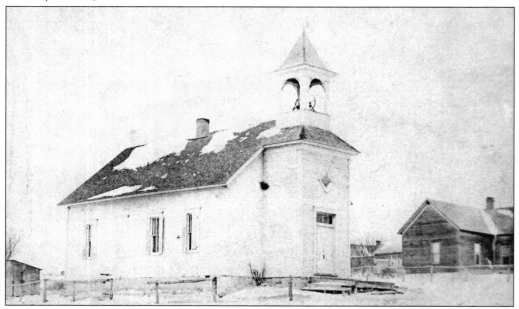

SLOVAK CHURCH. "Well, say we had a wedding here, it would last, continue for three days . . . Mostly from Saturday 'til Monday . . . They'd dance and drink . . . Then they'd all join hands and put the bride in the middle and they'd go in a circle and sing to her . . . sort of sad songs, you know, of marriage . . . they'd stick with it until she cried." (Quote by Andrew Smith and Ann Smith, Caucasian, lived near Buxton, oral history, 1981; photograph courtesy John Jacobs.)

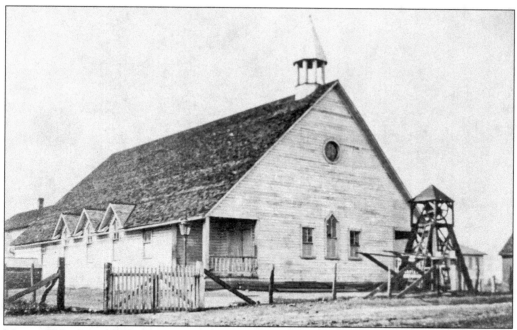

MOUNT ZION BAPTIST CHURCH. "I went to the Baptist [church]. It was very much like the inside of churches today. They had the piano and the organ, the pump organ, you know . . . we had the baptismal pool up in the church, and they had the choir." (Quote by Dorothy Collier, African American resident, oral history, 1980; photograph courtesy SHSI-DSM.)

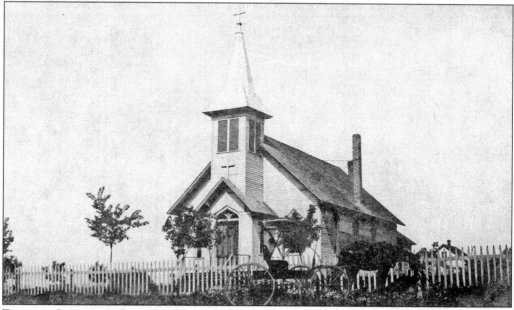

EBENEZER LUTHERAN CHURCH. "East Swede Town . . . consisted of about 35 buildings. The main feature of this small community was the Swedish Lutheran Church, which held its meetings in Swedish until World War I, when they changed to English." (Quote by Hazel Nylander, Caucasian resident, essay *Buxton Was Not Really a 'Tough Town,'* 1970; photograph courtesy of SHSI-DSM.)

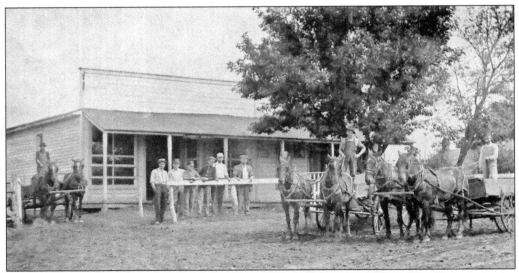

LARSON'S GROCERY STORE. "J.E. Larson, see he was a Swede. He run that big store. He had a pretty good size store and every week, on Monday or something like that, he'd go around and take orders. The next day your groceries would come. He'd come to your house and take orders and he'd go all over, clear over to [mine] number 10. Sometimes he would have a horse and buggy and other times he would just go around there in Buxton, he'd walk. He'd take orders until he got clear around and back up to the store. They'd just be wagonload after wagonload of groceries delivered there every day out of that store." (Quote by Earl Smith, Caucasian resident, oral history, 1981.) "I can remember mama pulling us on the sled or wagon to Larson's store." (Quote by Dorothy Collier, African American resident, oral history, 1980; both, photograph courtesy MCHS&M.)

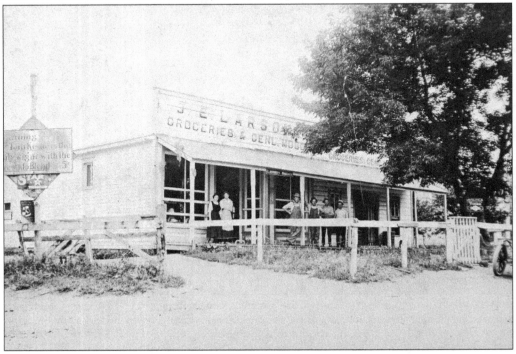

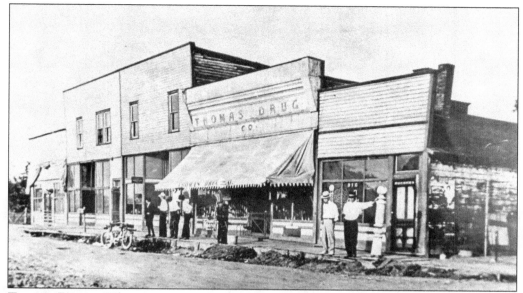

THOMAS BLOCK. "There was another drugstore . . . it was run by Alfred Thomas and John McBride, but they were white . . . They had a drugstore, just before you got to Coopertown." (Quote by Bessie Lewis, African American resident, oral history, 1981; photograph courtesy Michael W. Lemberger.)

GAINESTOWN. "My father Reuben Gaines Sr. decided to buy two forty acre plots near the soon to be constructed town [Buxton] . . . Gainestown grew rite across the road as Buxton grew and it was a small town . . . but the businesses there were numerous. Gaines Sr. sold a few front lots and a few acres to B.F. Cooper—a Pharmacist who built a drug Store; grocery store and dance hall." (Quote by Reuben Gaines Jr., African American resident, undated memoir; photograph courtesy John Jacobs.)

COOPERTOWN WITH PHARMACY (SECOND FROM LEFT). "[B.F.] Cooper was a pharmacist, he had a drugstore. Up over the top of his building, there was a . . . club. My dad belonged to it." (Quote

PER TOWN HOYTON IOWA

by Jacob Brown, African American resident, oral history, 1980; photograph courtesy Michael W. Lemberger.)

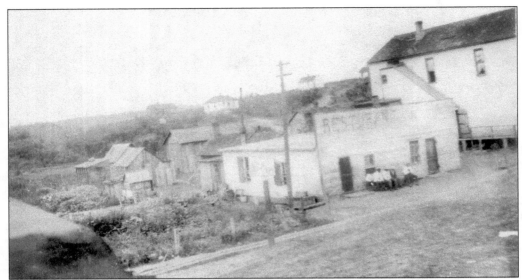

COOPERTOWN RESTAURANT (ABOVE) AND BUXTON HOTEL (BELOW). People sit in front of the restaurant above, while women stand in front of the Buxton Hotel dressed for lodge function below. "Then on back of there [Cooper's drugstore] . . . they built a hotel. Gaines Hotel [Buxton Hotel]. 'Course that was along in my later years . . . But on the back of that was what they called saloons. At that time, as long as Prohibition was in. And then I don't know who run this one right back of Cooper place, there was a pool hall back up there." (Quote by Jacob Brown, African American resident, oral history, 1980; both, photograph courtesy SHSI-IC.)

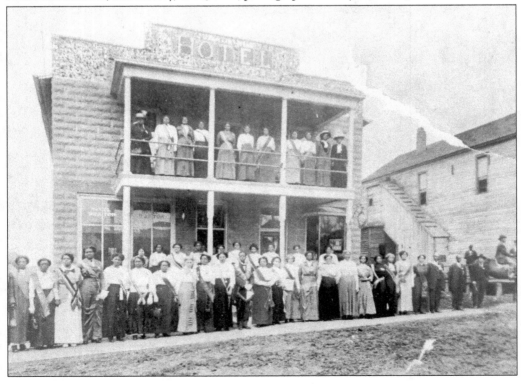

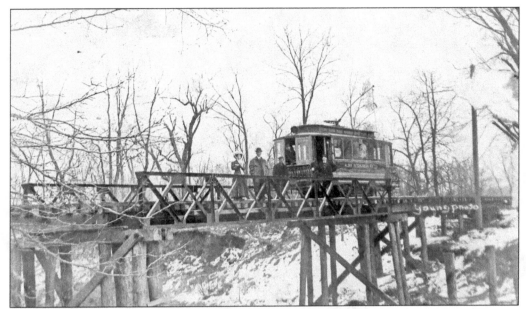

ALBIA INTERURBAN RAILWAY CAR, C. 1911. "Backers of the Albia Interurban had a Buxton line in mind. Albians saw Buxton as the great interurban prize, just as Oskaloosans did . . . The *Albia Republican* of December 24, 1908, for one, said . . . 'it is dollars to donuts we will have a line running into Buxton before Oskaloosa advances another foot' . . . Yet the project sputtered." (Quote from "Electric Traction Promotion in the South Iowa Coalfields" by H. Roger Grant, *The Palimpsest*; photograph courtesy MCHS&M.)

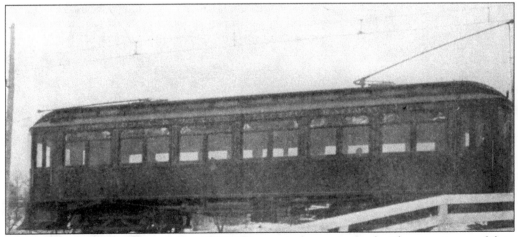

PROPOSED BUXTON INTERURBAN, C. 1907. "My cousin has a postcard with a streetcar on Main Street but then there was no streetcar in Buxton . . . but they were talking about running a track." (Quote by Dorothy Collier, African American resident, oral history, 1980; photograph courtesy Michael W. Lemberger.)

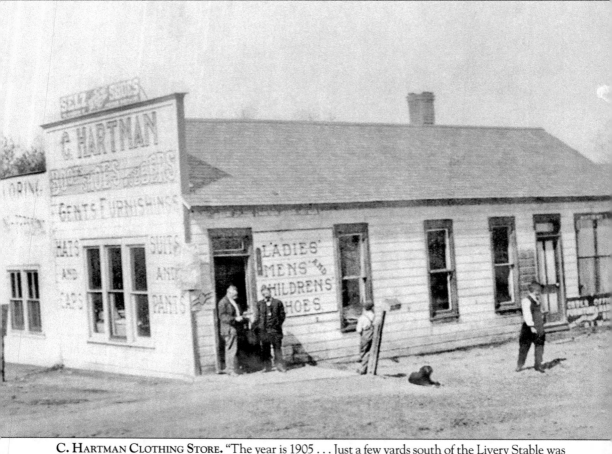

C. HARTMAN CLOTHING STORE. "The year is 1905 . . . Just a few yards south of the Livery Stable was a building that had just been finished all except the doors had not been hung to be used by Charley Hartman as a Shoe and clothing store and the north part as a jewelry shop." (Quote by Reuben Gaines Jr., African American resident, undated memoir; photograph courtesy SHSI-IC.)

Two

THE MINERS' LIFE

Buxton was first and foremost a mining town—meaning, of course, that the majority of the men worked in the mines controlled by the Consolidation Coal Company. According to the 1905 Iowa Census, of the 1,234 men employed by the Consolidation Coal Company, 94 percent of them listed their occupation as "miner." In 1915, that percentage had increased to 97, despite the fact that the total number of employees had dropped by 161.

This percentage is higher than the 70–80 percent of the mining workforce reported by smaller mines throughout Iowa. Perhaps because Buxton respondents selected "miner" when, in fact, they were a mule driver or held some other mine-related job. Or perhaps it was because Consolidation Coal Company mines were more modern—for example, the use of electrified motorcars to pull coal cars would result in the need for fewer mule drivers.

Consolidation Coal Company had acquired the reputation of not only being the largest mining company in Iowa and implementing the latest in mining technology, but the safest. The company established a Mine Safety Inspection Committee, which had a designated representative from each mine tasked with the inspection of their mine and the submission of a monthly report to the company. The formation of this committee earned the company rare praise from inspector Rhys T. Rhys in 1912 for going above and beyond the requirements of state law to make mining safer for their employees. Though the company may have taken more steps than other mines to make conditions safer, mining was still dangerous, with deaths and accidents appearing in the papers frequently.

While many of those in mining who were interviewed may have appreciated the company for the above qualities, the most frequently cited benefit of working for the Consolidation Coal Company was the pay. Not only were they paid fairly, they worked year-round. In most mines in Iowa, the coal produced was used for household or business consumption, which went down in the summer, resulting in less demand and miner layoffs. Since the coal mined for the Consolidation Coal Company was used by the Chicago & North Western Railroad and business was booming, Buxton miners did not experience layoffs.

Buxton resident Earl Smith summed things up by saying, "Anybody that wanted to work could work in Buxton."

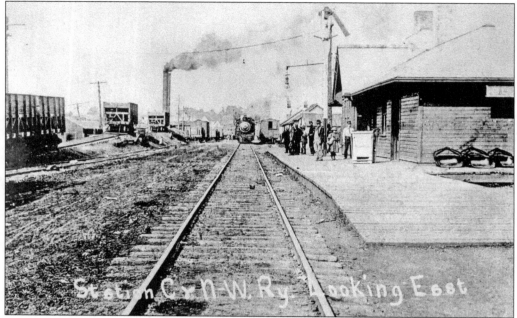

Train Pulling in, Buxton Depot. "At one time, there were five trains coming in there [Buxton] at one time. There was [trains coming from] 12, 13, 14, 15, and 16 . . . different mines." (Quote by Hucey Hart, African American resident, oral history, 1980; photograph courtesy Michael W. Lemberger.)

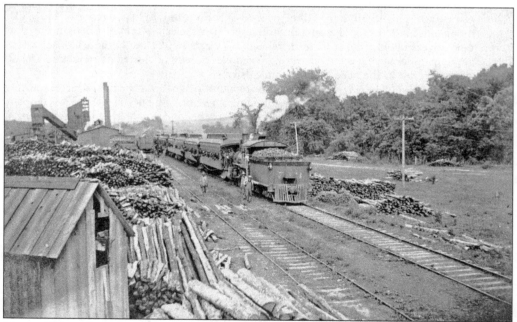

Miners' Train Leaving Mine No. 10. "They [miners] take the miner's train out. Passenger cars with the seats taken out and just a bench along each side and a bench in the middle—that's the way we rode the miner's train." (Quote by Carl Kietzman, Caucasian resident, oral history, 1981; photograph courtesy SHSI-DSM.)

BUXTON MINE, C. 1905. "Work began about 7:00 AM and the first thing the men did in the morning was wait for the 'cage' or elevator like conveyance to take the miners to the bottom of the shaft . . . It took about thirty or forty minutes to lower 600 men down into the mine." (Quote by Reuben Gaines Jr., African American resident, undated memoir; photograph courtesy SHSI-IC.)

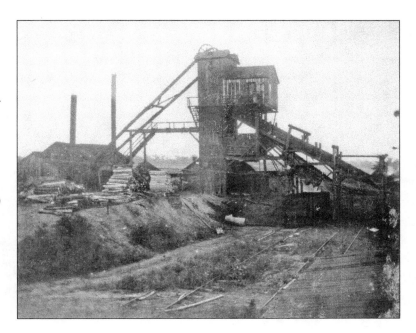

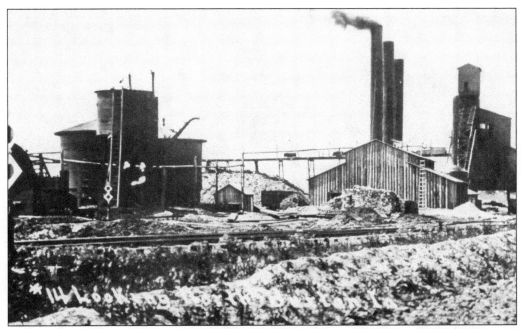

BUXTON MINE NO. 14. "See, they have two entries. One, it was called the airshaft and they have a great big fan on top . . . that turn over and over. See, that fan drives that air down in the mine and circle around and come out through that entry . . . so that way it's just as cool down there as it is up here." (Quote by Hucey Hart, African American resident, oral history, 1980; photograph courtesy Michael W. Lemberger.)

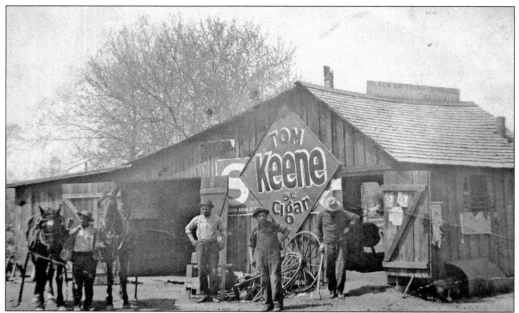

BLACKSMITH SHOP IN BUXTON. "They sharpened the picks and augers at the mines [not at the blacksmith]." (Quote by Herman Brooks, African American resident, oral history, 1981; photograph courtesy John Jacobs.)

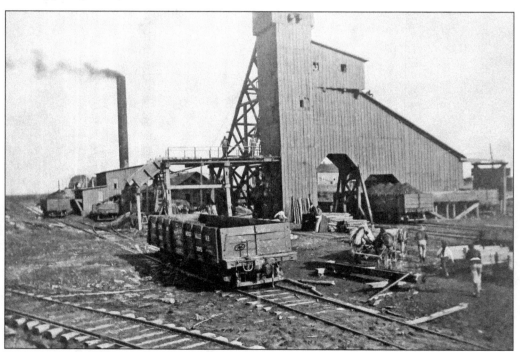

BUXTON MINE. "They never allowed a woman to go [in the mines]. If a woman went down in the mines, that was always bad luck. You were sure that somebody was gone be killed." (Quote by unidentified woman with Gertrude Stokes, oral history, 1981; photograph courtesy John Jacobs.)

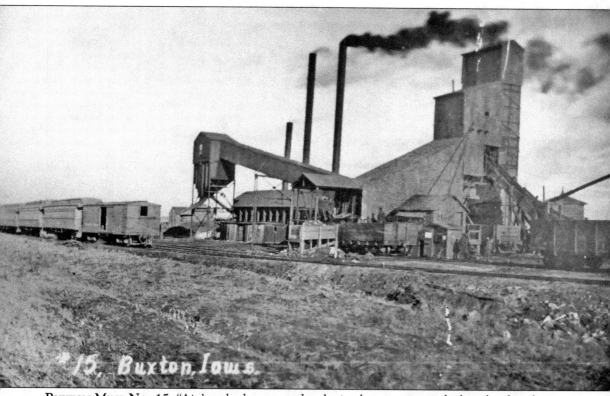

*15, Buxton, Iowa.

BUXTON MINE NO. 15. "Ain't nobody supposed to be in the mines at night but the shot firer, when they're shooting . . . there's a little brass check with your number on it and when you come up at night, you had to hang it up and before the train would leave, the first aid men would go over that board and see if every check was hanging there." (Quote by Clyde Wright, African American resident, oral history, 1981; photograph courtesy Michael W. Lemberger.)

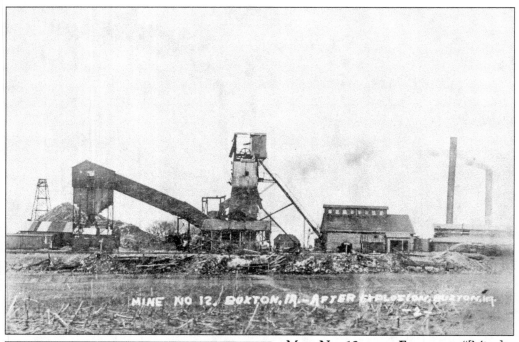

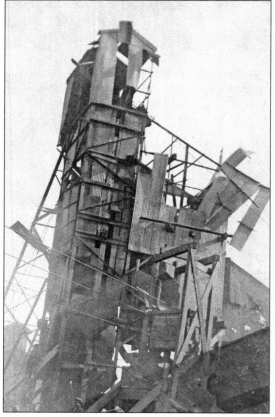

MINE NO. 12 AFTER EXPLOSION. "[Mine] number 12 blowed up . . . I was standing out in the yard and my husband had worked that day out in number 12. They all had come home. These men went back that night to light they shots, you know, and when they went back in, they blowed. I was standing out in the yard. I can remember it just as well." (Quote by Susie Robinson, African American resident, oral history, 1981; photograph courtesy John Jacobs.)

CLOSE-UP OF MINE NO. 12 AFTER EXPLOSION. "The shot firer is a man that goes in after the miners are through working. He goes in there and when they [miners] got their [blasting] powders in a thing where they shoot coal [hole/ shots], he goes in there and lights the fuse, and when that shot go off, he might be halfway over the mine when it goes off." (Quote by Leroy Wright, African American resident, oral history, 1980; photograph courtesy John Jacobs.)

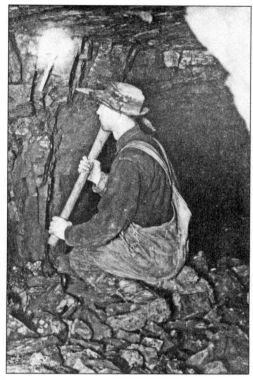

BUXTON MINERS. "The only ones that got paid by the hour was the company men. Now, the diggers, the people that dug the coal, wudn't no company men. The company men were your trappers, your timbermen, your tracklayers, your mule drivers, your cagers, and your dump men. You call them dump men, the guy that dumped the coal . . . But the guys that mined the coal was on their own. We was in there nine hours and if you didn't load no coal, you didn't get nothing. See, wudn't no hour rate, you didn't get nothing. That's the way it went. Now, we had some men would load as high as 12, 14 cars a day." (Quote by Hucey Hart, African American resident, oral history, 1980; right, photograph courtesy SHSI-IC; below, photograph courtesy Dave Johnson.)

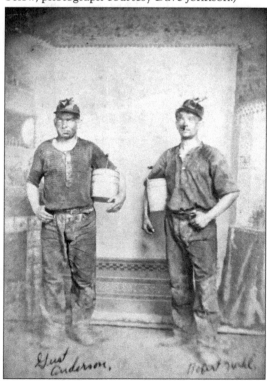

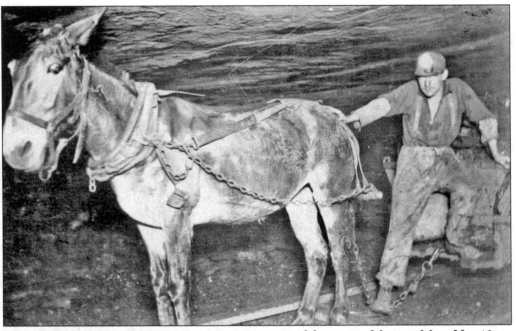

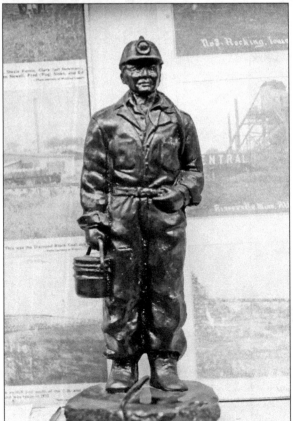

MINER AND MULE IN MINE NO. 12.
"What I really liked about it [mines] was driving mules, for the simple reason that all youngsters, teenagers, they started driving mules: They thought they was a man . . . Made the girls like you 'cause you were a man mule driver . . . And to me it one of the most dangerous jobs in there." (Quote by Hucey Hart, African American resident, oral history, 1980; photograph courtesy SHSI-DSM.)

MINER COAL STATUE. "They had . . . lump coal, range coal, and nut coal. Nut coal you used more in the summertime because it would burn up quick and you'd keep from heatin' your house. The range coal, you'd probably use in the fall of the year and the spring of the year and in the wintertime you'd use lump coal in the heating stove to keep through the night." (Quote by Carl Kietzman, Caucasian resident, oral history, 1981; statue courtesy of MCHS&M; photograph courtesy Michael W. Lemberger.)

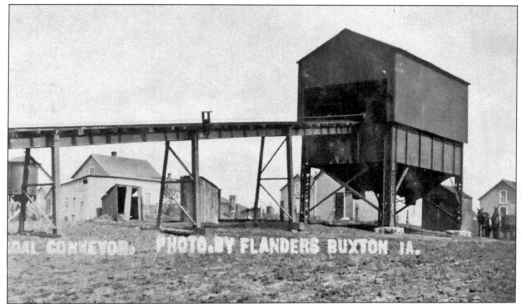

COAL CONVEYOR AT COAL CHUTE HILL, C. 1908. "When they brought it [coal] from the railroad track here, they had a whatcha call thing to bring the coal here from up the top of that hill, into a big bin, see, and the . . . carts or wagons . . . would go right up in there . . . and fill the wagons up and deliver from house to house." (Quote by Elmer Buford, African American resident, oral history, 1981; photograph courtesy John Jacobs.)

VIEW FROM COAL CHUTE HILL. "In the wintertime, see, it was dark in the wintertime at 6:00 and it's the prettiest thing you ever seen to stand up on top of the Coal Chute Hill. Look like a whole city moving. All the miners had the lamps on their heads, you know, walking home. It was one of the beautifulest thing you ever seen." (Quote by Hucey Hart, African American resident, oral history, 1980; photograph courtesy SHSI-IC.)

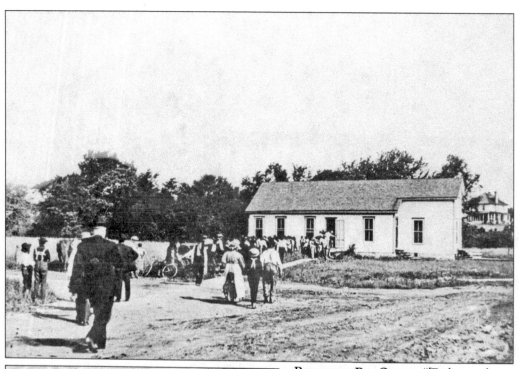

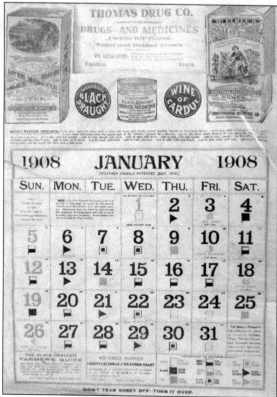

PAYDAY AT PAY OFFICE. "[Father and I] averaged around $60 every couple of weeks a piece . . . a lot a fellers could make a $100 in two weeks . . . depends on what kind of place [mine room] you had." (Quote by Jacob Brown, African American resident, oral history, 1980; photograph courtesy SHSI-IC.)

THOMAS DRUG CALENDAR, 1908. "You'd get paid twice a month. Payday was the first Saturday after the 5th and the first Saturday after the 20th." (Quote by Carl Kietzman, Caucasian resident, oral history, 1981; photograph courtesy John Jacobs.)

MINER'S WORK STATEMENT. "That was the money you drew on your work statement . . . Your expenses were taken out of that. If you had a store bill, that was taken out. Of course your [blasting] powder, you had to pay for that. Everything you wore, you paid for. All the tools that you used, you paid for." (Quote by Carl Goodwin, Caucasian resident, oral history, 1980; photograph courtesy Michael W. Lemberger.)

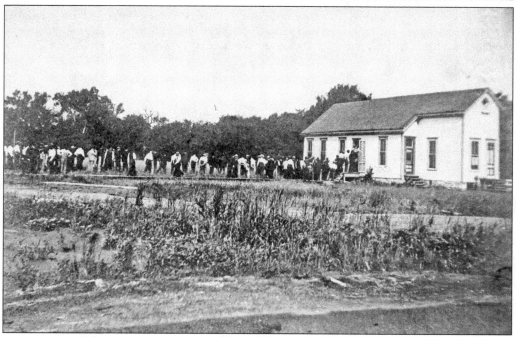

MINERS IN LINE ON PAYDAY. "They paid you in $20 gold pieces and $10 gold pieces and $5 gold pieces . . . some pennies, nickels, dimes." (Quote by Walter Plum, Caucasian resident, oral history, 1981; photograph courtesy John Jacobs.)

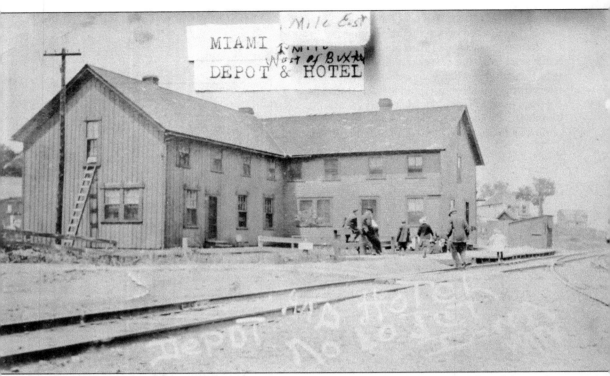

MIAMI HOTEL IN MIAMI, IOWA. "The railroad company had a hotel there . . . A lot of them, they didn't come in and go right out . . . they laid over, well that's where they stayed, the engineers and the firemen and the brakemen and so forth." (Quote by Jacob Brown, African American resident, oral history, 1980; photograph courtesy Michael W. Lemberger.)

Three

THE BIG SHOTS OF BUXTON

While former residents could recall various individual names and businesses, there were several names of successful and/or wealthy African Americans that surfaced repeatedly.

Some of these individuals were successful in Muchakinock and carried their success over to Buxton. Minnie B. London was one. A well-known teacher in Muchy, she continued to be a respected instructor in Buxton, eventually becoming school principal. B.F. Cooper was another. Not only did he own the largest pharmacy in Buxton, in 1900 he organized the Buxton Wonders baseball team, which he managed until 1914. Reuben Gaines Sr. continued amassing land and houses in Buxton, as well as saloons and other businesses, while passing along his business acumen to Reuben Gaines Jr., who continued in his father's footsteps after Gaines Sr.'s death. Reuben Gaines Sr. built the Buxton Hotel, a concrete structure with steam heat, for $10,000.

Hobert "Hobe" Armstrong also continued amassing land and houses, renting them to both races, while deepening his relationship with the company. He continued to recruit African Americans from the South in the early years of Buxton, served as a mule buyer, and monopolized the meat market business, being the only independent business allowed to use the company's check off system—a credit system whereby residents could buy goods on credit with payment to be deducted from their future pay.

Then there were attorney George Woodson and Dr. E.A. Carter, both sons of ex-slaves. George Woodson became a well-known attorney in Iowa and established the Iowa Negro Bar Association and the National Bar Association in Des Moines. Dr. Carter became the first African American to obtain a medical degree from the State University of Iowa.

According to the *Albia Republican*, Lottie Armstrong Baxter "had immediate supervision of the Buxton Savings bank of which she was second vice president, director and stockholder."

The *Iowa State Bystander* reported that Hattie B. Hutchinson became the first African American woman to obtain a pharmacy degree in Iowa. She worked in a pharmacy with her husband.

These are just a few of the "Big Shots" of Buxton.

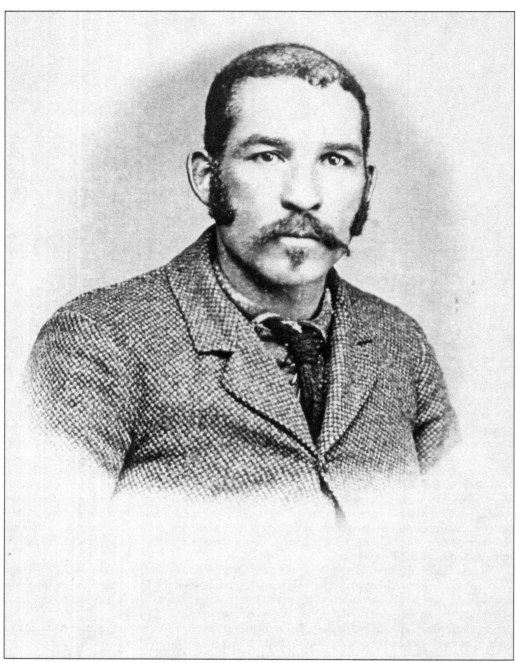

HOBERT "HOBE" ARMSTRONG. "I wrote his obituary. He was born in Knoxville, Tennessee, 1850. He became an orphan when he was 12 . . . He was self-educated and there was Dr. Purdue that raised him . . . he [Dr. Purdue] was a white man . . . I don't know [how Hobe got to Muchy] . . . he got the concession from the coal company to operate the meat market, then he got to be mule buyer for the company . . . I think he had 16, 17, 18 farms, something like that. He invested his money. He was a teetotaler . . . [He had] the butcher shop and he had the slaughterhouse [in Buxton]." (Quote by Carl Kietzman, Caucasian resident, oral history, 1981; photograph courtesy John Jacobs.)

REUBEN GAINES SR. "Reuben Gaines Sr. owned a farm of 80 acres in Mahaska County . . . [he] owned the Hotel . . . three saloons; and a wholesale place; Millinary Shop; tobacco factory cigar store; livery Stable; barber shop; jewelry store; taylor shop and a dozen dwelling houses, and a grocery store operated by Elijah London. These shops and business places were all rented except: the saloons; and wholesale place; the drug store; the dance hall and the Elks Club." (Quote by Reuben Gaines Jr., African American resident, undated memoir; photograph courtesy ISU.)

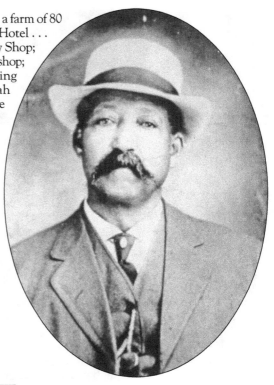

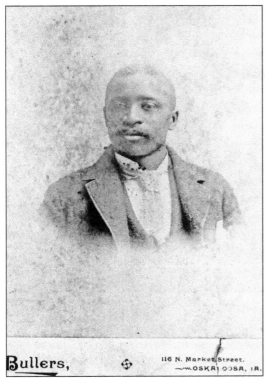

B.F. COOPER. "That's the guy that started the Buxton Wonders baseball team, Cooper. He was a druggist there . . . And that's the reason they called it Coopertown, 'cause he was down there. He was kind of a big shot, you know." (Quote by Earl Smith, Caucasian resident, oral history, 1981; photograph courtesy of a private collection.)

43

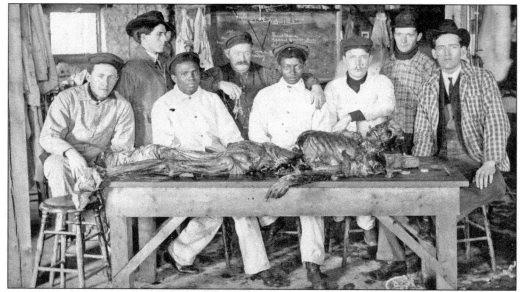

ANATOMY CLASS AT STATE UNIVERSITY OF IOWA, IOWA CITY, C. 1900. Pictured third from the left is Edward A. Carter. "He entered the College of Medicine in 1903 and ranked always as one of the best in his class in spite of the fact that during his whole university course he was forced to earn his living . . . On June 15 he will receive the degree of M.D., being the first and only negro to have graduated from the College of Medicine at S.U.I." (Quote from *Oskaloosa Thursday Herald*, June 6, 1907; photograph courtesy SHSI-DSM.)

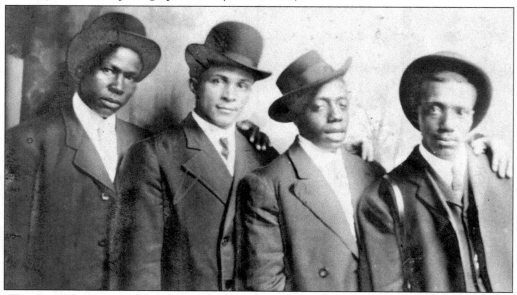

"THE BIG FOUR" POSTCARD, C. 1910. Pictured are, from left to right, unidentified, John Drake, Dr. Lindford Willis, and James A. Spears. "They had colored dentists, the one that I went to . . . Willard or something like that, I forget just what his name was. I had a lot of work done by him . . . he did very good work." (Quote by Anna Olsasky, Caucasian, lived near Buxton, oral history, 1981.) "James Spears. He was a colored doctor, ah, lawyer." (Quote by Jacob Brown, African American resident, oral history, 1980; photograph courtesy SHSI-DSM.)

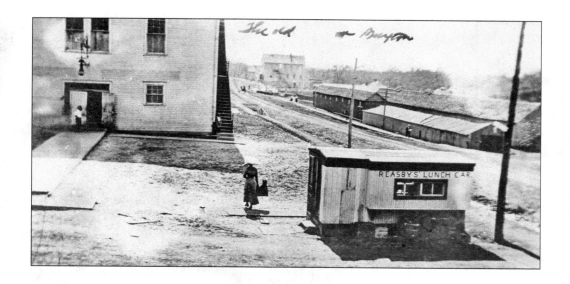

LOUIS REASBY LUNCH CAR (ABOVE) AND BUXTON SAVINGS BANK NOTE (BELOW). "He'd [father] . . . go round this crap game and sell [hamburgers, wiener sandwiches, boiled eggs] from the woolen basket 'til he saved enough money, half the money to build this little lunch car in Buxton and then . . . he went and borrowed. Ms. Christian, she was the woman headed the bank and grocery store, and then she loan the rest of the money to build this little lunch car. That's the way he got started. He had $250, said it cost him $500 to build it, and she loan him the other $250 . . . And then my mother used to cook hamburgers and chicken at home and every Saturday, he must have sold 200 or 250 chicken." (Quote by Harold Reasby, African American resident, oral history, 1981; both, photograph courtesy John Jacobs.)

$		Buxton, Iowa,	191

days after date, promise to pay to the order of the

BUXTON SAVINGS BANK
AT ITS OFFICE IN BUXTON, IOWA,

the sum of _____ **Dollars**

value received, with eight per cent interest from date, payable semi-annually, and a reasonable attorney's fee if suit is instituted on this note.

The makers, endorsers and grantors of this note agree to pay a reasonable attorney's fee, if suit is brought herein, and consent that a Justice of the Peace may have jurisdiction to the amount of Three Hundred Dollars, and we hereby authorize the holder hereof to extend the time of payment of the same, or any part thereof, from time to time, by the reception of interest in advance or otherwise, without impairing our several or joint liabilities.

Due_____

No._____ P. O. Address_____

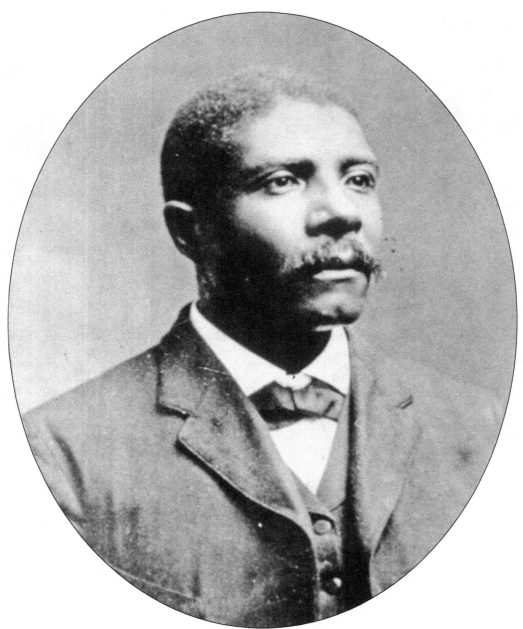

GEORGE WOODSON. Woodson was a noncommissioned officer in the US Army, 25th Infantry, and president and founder of the Iowa Negro Bar and National Bar Association in Des Moines. "George H. Woodson the most prominite and successful lawyer in Buxton . . . threw his hat in the Republican Political Ring to represent the District in Monroe County for a seat in the Iowa House . . . Woodson Campaigned constantly and I drove him around to quite a few places in my Automobile . . . In the primary, Woodson got practilly all the republican votes and half of the Democrates and in the general election Woodson was defeated as badly as he had won in the primary . . . it was yet too early to elect a black man to that position." (Quote by Reuben Gaines Jr., African American resident, undated memoir; photograph courtesy ISU.)

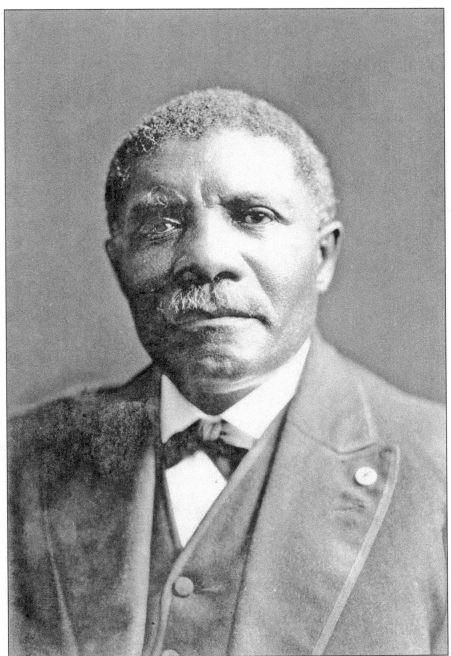

UNDATED PHOTOGRAPH OF GEORGE WOODSON. "Attorney George H. Woodson went to Des Moines to appear before the committee on Cities and Towns in the Iowa Legislature, urging his fight for the incorporation of Buxton . . . Mr. Woodson . . . will declare . . . that it is essential for better government and for better convenience, including water supply, sewer and light services, and city improvements in general, and that the bill will serve as a curb to alleged improper domination of a civil life by the corporations which own such towns." (Quote from the *Oskaloosa Thursday Herald*, March 22, 1906; photograph courtesy SHSI-DSM.)

"Flying High" Novelty Postcard. Pictured are, from left to right, E.A., Davis, Clinton, and Clayborne Carter. At lower left is the Perkins Hotel. "This man by the name of Andrew Perkins, he built a hotel there and he ran a hotel. He had several boys and he had—his girl worked in the post office." (Quote by Bessie Lewis, African American resident, oral history, 1981) "Near the depot Anderson Perkins and Son operated a hotel and confectionary. They advertised good meals and first class service. Hotel rates $1.00 and $1.50." (Quote from Minnie B. London, African American resident, memoir *As I Remember*; photograph courtesy SHSI-DSM.)

"I remember Lottie. Oh, yes, she run the bank. She managed it, I remember. I remember her being the manager of the bank." (Quote by Charles Lenger, Caucasian resident, oral history, 1981; photograph courtesy SHSI-DSM.)

MALE EMPLOYEES AT COMPANY STORE. "There are fifty men and about thirty-five ladies employed in this great building, of whom eighteen are colored. Mr. E.C. Strong, a colored gentleman, is the oldest man in the company's employ, from a point of service, having been with it for about twenty-one years." (Quote from the *Iowa State Bystander*, October 20, 1911; photograph courtesy John Jacobs.)

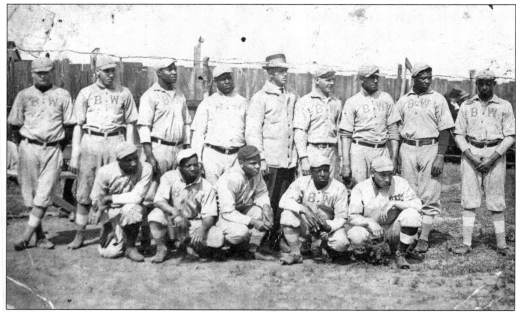

BUXTON WONDERS BASEBALL TEAM. "I've seen them play the Kansas City Monarchs, New York Black Yanks, Chicago Union Giants, Minneapolis Gophers . . . Nobody beat [the team] in them days." (Quote by Charles Taylor, African American resident, oral history, 1980; photograph courtesy AAMI.)

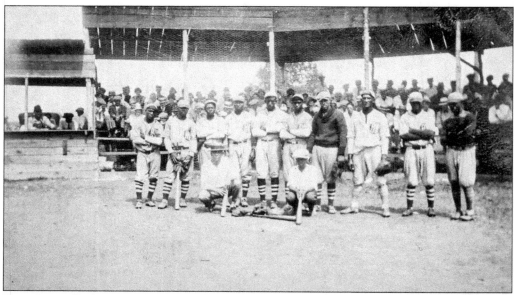

BELIEVED TO BE BUXTON WONDERS. "I remember when they'd knock a fly and he'd [John Lewis/Zebo] turn two somersaults and get up and catch it . . . never miss it." (Quote by Charles Taylor, African American resident, oral history, 1980; photograph courtesy John Jacobs.)

HERMAN BROOKS WITH UNIDENTIFIED WOMEN, C. 1910. "He was catcher in the Buxton Wonders, Herman Brooks. And he will be 94 in December." (Quote by Vaeletta Fields, African American resident, oral history, 1980; photograph courtesy SHSI-DSM.)

HERMAN BROOKS IN "B" SHIRT, C. 1910. "Well now, we [Buxton Wonders] really didn't play for money. All we wanted was expenses guaranteed and have a good time and play ball. We loved the sport, you see." (Quote by Herman Brooks, African American resident, oral history, 1981; photograph courtesy SHSI-DSM.)

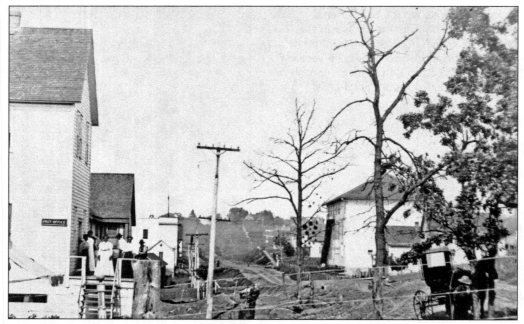

BUXTON POST OFFICE (LEFT) AND YMCA (RIGHT). "Postmaster. He was black . . . Mr. Mills. His son Eddy was the secretary at the YMCA." (Quote by Carl Kietzman, Caucasian resident, oral history 1981; photograph courtesy John Jacobs.)

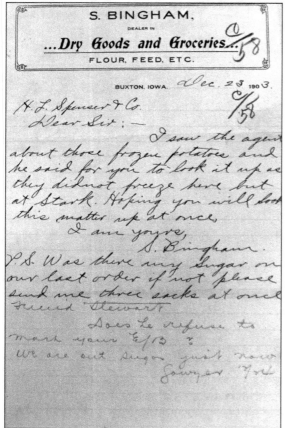

LETTER FROM S. BINGHAM GROCERY. "The state lecture bureau movement, which was undertaken last fall to spread information about the progress of the negro and to enlist support for him in his efforts to lift himself up, will be continued and a permanent organization formed for this purpose at a meeting of prominent negroes of Iowa at Oskaloosa on Jan. 1 and 2 . . . The following prominent negroes have been appointed to act as delegates . . . Buxton . . . Stewart Bingham." (Quote from the *Evenings-Times Republican*, December 30, 1903; photograph courtesy John Jacobs.)

HERMAN BROOKS (LEFT) AND R. HUBERT
LONDON (RIGHT), RESIDENT, C. 1910.
"That's Dr. London, that's my cousin [and
me]." (Quote by Herman Brooks, African
American resident, oral history, 1981;
photograph courtesy SHSI-DSM.)

ENVELOPE FROM JAMES ROBERTS. "Mr. Jas. Roberts is a cigar-maker, in fact the only colored cigar-maker in Iowa. The Big 4 and Iowa Boy are his leading brands." (Quote from *Iowa State Bystander*, December 6, 1907.) "The cigar factory here is owned by James Roberts, a very exemplary young man who came from the South a few years ago and entered into the cigar business, and by close attention to business . . . he has succeeded." (Quote from the *Iowa State Bystander*, November 15, 1918; photograph courtesy John Jacobs.)

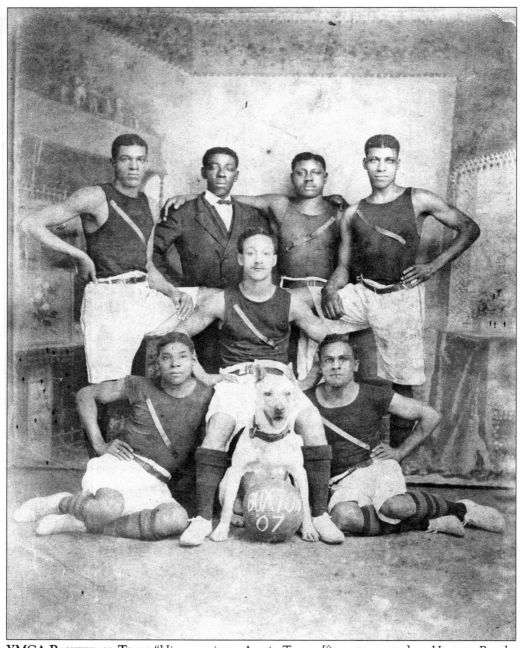

YMCA Basketball Team. "His name is . . . Austin Turner [first row, center] . . . Herman Brooks [first row, left] . . . Leonard Cary [second row, second from left]." (Quote by Herman Brooks, African American resident, oral history, 1981; photograph courtesy AAMI.)

Four

LIVING THE DREAM

Since the mines were productive and the men worked year-round (until Buxton's decline), many families in Buxton were better off than those in other mining towns. Many households had multiple males, such as fathers and sons, working in the mines, which provided additional income. Unlike other mining towns, many wives did not seek work outside the home—though some took in boarders to bring in extra income.

Oliver Burkett, an African American resident, said, "Papa would always have this gold money . . . When I was young, we wasn't nothing but kids, he used to have this $20 gold piece always go on his watch chain."

This gives the impression that money flowed freely in Buxton. Reuben Gaines Jr., an African American businessman in Buxton, confirmed it in an undated memoir, "I went to the Bank every monday after pay-day to get a Sight Draft to make payment on merchandise we had received and I had never noticed anybody making an investment or establishing a Saving account. The miners received excellent pay according to the economy at that time. In any event or manner the money flowed freely."

But not everyone had expendable income. Lola Reeves, a teacher in Buxton, mentioned lodge parties and dances but being unable to afford to go. Mattie Murray mentioned her father seeing nothing but a snake—a red line—on his pay statement, meaning that after all expenses had been deducted from his pay, he had nothing left over.

But regardless of income level, residents could find recreational outlets in Buxton. There were churches and their associated activities; movies, programs, swimming, and pool tables at the YMCA; baseball games; lodges and social clubs for men and women; and picnics and parades on holidays. In Coopertown and Sharp End, drinking and gambling were available.

While the *Iowa State Bystander*, the prominent African American paper in Iowa, included detailed reports of the business and social news of Buxton, other papers seemed to focus on the drunkenness and murders that occurred, seemingly on paydays. While residents agreed that these things occurred—namely in Sharp End and Coopertown—they did not feel it was worse than any other town. If one was looking for trouble, one could find it. The majority of Buxton residents did not go looking for it.

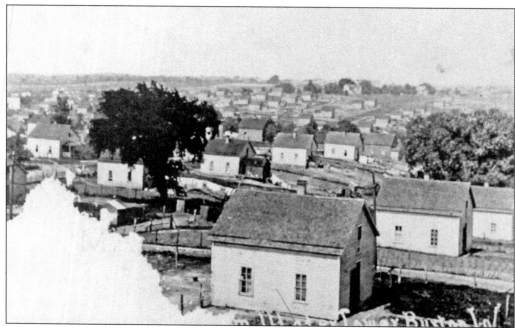

"**View From Water Tower.**" "There were four houses per acre . . . they were story and a half. Five-room house rented for $7 per month . . . Two bedrooms upstairs and you had a kitchen and a dining room and some had a bedroom downstairs. And then they had a six-room house—that was a kitchen built on. Those rented for $8 a month." (Quote by Carl Kietzman, Caucasian resident, oral history, 1981; photograph courtesy SHSI-IC.)

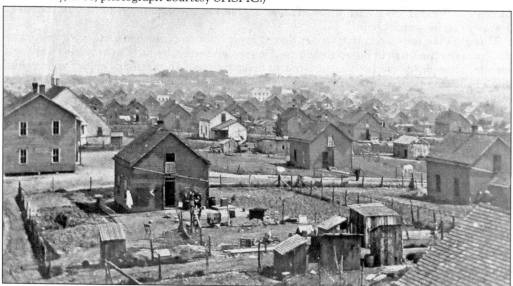

Buxton Houses and Yards. "Everybody had a alley and every yard was fenced in . . . you could get your coal, they could [come into the alley] and put it over in the coal shed . . . then there was the toilet and . . . oh, say, from about the alley to about the end of the house was a garden." (Quote by Dorothy Collier, African American resident, oral history, 1980; photograph courtesy John Jacobs.)

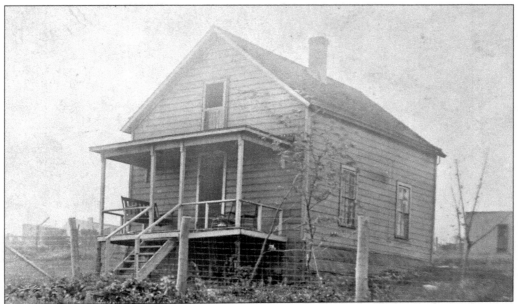

COMPANY HOUSE WITH PORCH ADDED ON. "No, they [houses] didn't have no plumbing. They had outdoors . . . we had lamps. No, we didn't have no electricity." (Quote by Jacob Brown, African American resident, oral history, 1980; photograph courtesy SHSI-DSM.)

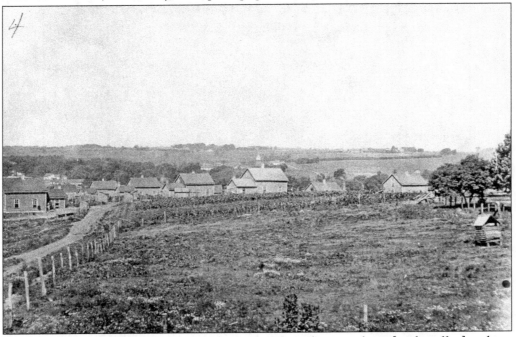

GENERAL VIEW OF BUXTON. "Water was scarce and you'd just go down [to the office] and put your order in for a load of water just like you did for a load of coal . . . and they deliver your water, the water tank would bring your water and put it on the small side [of the cistern], and it would filter through to the big side." (Quote by Clyde Wright, African American resident, oral history, 1981; photograph by AAMI.)

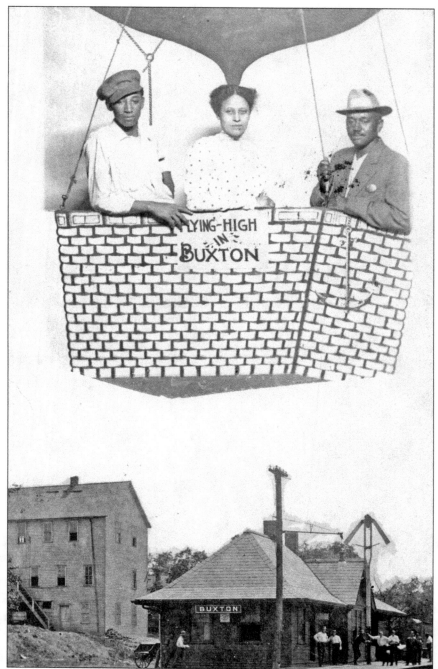

Novelty Postcard. Pictured are, from left to right, Jim and Rose Warren with Will Cuzzens. "The men made good money, and when they were working, I guess they thought Buxton was gonna last forever. They were very extravagant . . . The men would have their watch charms . . . Vest pocket watches with charms. They'd have a $50 gold piece or something on there . . . They made money, good money, but they spent it, too." (Quote by Lola Reeves, African American resident, oral history, 1980; photograph courtesy SHSI-DSM.)

COMPANY PAY OFFICE. "During the month of December the Buxton Coal Co. based on the amount of defense funds paid to this office, paid their employees $997,750 for the month. This is exclusive of the amount paid to their clerks, mine foremen, teamsters, and a host of other employees. This will give the public some idea of the volume of business done in the community." (Quote from the *Oskaloosa Thursday Herald*, February 16, 1907; photograph courtesy John Jacobs.)

ILLUSTRATED POSTCARD OF TRAIN DEPOT. "There was a . . . lot of money [in Buxton]. You know, that money used to come in there on that train and they'd unload it there at the depot, and two guys would come up there and put it in an old buggy or something and haul it over to the pay office. Nobody ever thought of robbing." (Earl Smith, Caucasian resident, oral history, 1981; photograph courtesy AAMI.)

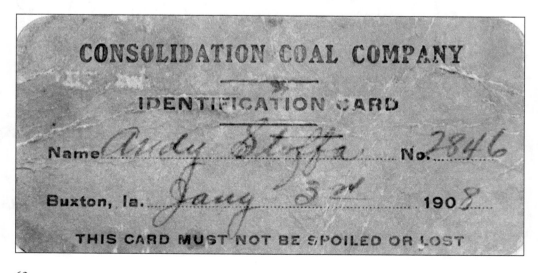

This card is issued by the CONSOLIDATION COAL COMPANY as an identification card and must not be spoiled or lost. Not valid unless signed by N. P. Herrington, Cashier.

N. P. Herrington
Cashier,
C.C.C.

MINER'S IDENTIFICATION CARD. "So many times the boys would want to go in the mines with their fathers at an early age and I think they did . . . They made such good money that the boys went to work early and they didn't strive for higher education . . . they would falsify their age and go to work so they could make money for the family." (Quote by Lola Reeves, African American resident, oral history, 1980.) "The average guy working in the mine, my dad and all of them, they didn't have much more than a second or third grade education. Most of them had no education." (Quote by Charles Taylor, African American resident, oral history, 1980; both, photograph courtesy John Jacobs.)

CONSOLIDATION COAL COMPANY

IDENTIFICATION CARD

Name Andy Stiffa No. 2846

Buxton, Ia. Jany 3rd 1908

THIS CARD MUST NOT BE SPOILED OR LOST

TAILORS IN COOPERTOWN SHOP, 1914.
The tailors pictured are, from left to right, unidentified and George Neal. "You go in there [company store] if you want a suit of clothes . . . get a tailor-made suit for about $30, the best . . . If you want to borrow $25 or $30 . . . you pay it back . . . $2 or $3 every two weeks. Your credit was good." (Quote by Hucey Hart, African American resident, oral history, 1980; photograph courtesy AAMI.)

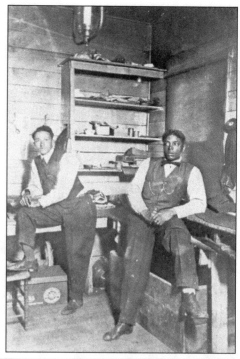

THE CARTER MEN. Pictured from left to right are Edward A. Carter, Clinton Carter, Clayborne Carter, Davis Carter, and Lawrence Carter. "Oh, they used to dress. Most of them colored guys, boy, they really dressed." (Quote by Mike Onder, Caucasian resident, oral history, 1981.) "Yeah, we dressed. They were great dressers. And then the goods and stuff. That broadcloth and all that, you can't buy today." (Quote by Herman Brooks, African American resident, oral history, 1981; photograph courtesy SHSI-DSM.)

"OLLIE ELLIS, BUXTON IA" (WRITTEN ON PHOTOGRAPH). "The women would dress nice. It was at a time when the women were wearing these hats that you see in the movies with these great big ostrich plumes on them and pay big prices for them, and they had their lodges that they would attend, the grand lodges, and always go to these conventions." (Quote by Lola Reeves, African American resident, oral history, 1980; photograph courtesy SHSI-IC.)

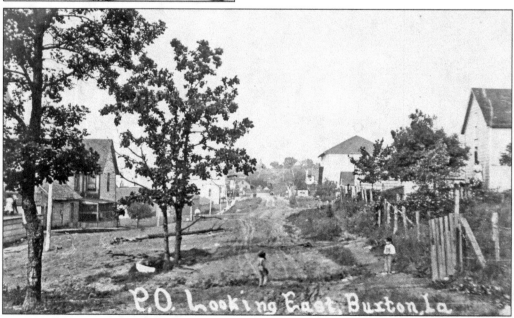

"P.O. LOOKING EAST." "On Monday, the women would put on the best they had and parade from Coopertown up to Sharp End . . . go up there and have a good time and go on back home in time to get their supper . . . when 4:00 come, that miner's train was bringing them men home. We got to be there and have their supper ready, have that water ready for the men to take their bath." (Quote by Gertrude Stokes, African American resident, oral history, 1981; photograph courtesy John Jacobs.)

MACNOLA AND VASCILLA SEARS, C. 1910
(RIGHT, IDENTIFIED BY DAVID GRADWOHL),
AND RUSSELL AND DORIS CARTER, C. 1910
(BELOW). "It was a coal mining town . . .
Now, the people that didn't dig coal were
those that worked in the businesses . . .
And that would be a small percentage
. . . they would be [in the upper class] . . .
It was the style of life [that classed people].
When I say people were class conscious, it
was not going around with your nose stuck
in the air . . . It just happened. Me and
my friends and my church and my choir
. . . and if you were not in my church or
my choir or in my lodge, you just weren't."
(Quote by Marjorie Brown, African
American resident, oral history, 1980;
both, photograph courtesy SHSI-DSM.)

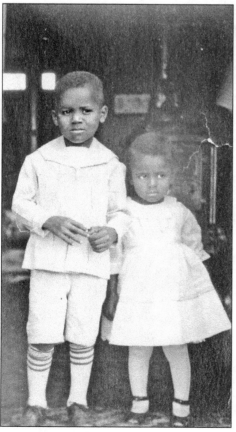

NEALEY JONES REEVES AND P.A. REEVES, RESIDENTS, C. 1910. "The latest organization is the Ladies' Industrial Club. They have regular weekly meetings, each lady bringing some kind of work, they exchange ideas, assist each other and so on—then they lunch! The club has a good membership and more are joining each week. Last Wednesday the club met at the home of Mrs. P.A. Reeves, after spending a profitable working hour Mrs. Reeves spread a delightful luncheon." (Quote from the *Iowa State Bystander*, February 6, 1903; photograph courtesy SHSI-DSM.)

ICE CREAM SOCIAL AT THE HOME OF MRS. MAUD BURKETT (ACCORDING TO SHSI-DSM), C. 1910. "Our social life was church. It was lodge. It was family. And then these organized social clubs." (Quote by Marjorie Brown, African American resident, oral history, 1980; photograph courtesy SHSI-DSM.)

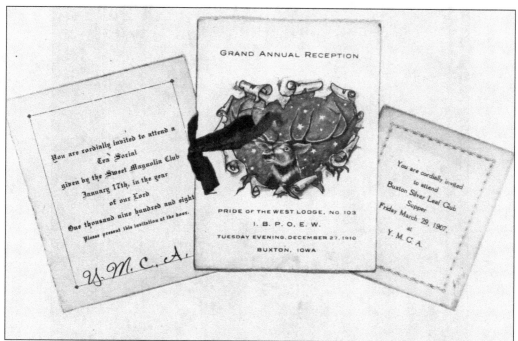

PROGRAMS FOR WOMEN'S SOCIAL ORGANIZATIONS. "Not only did Buxton's black women take part in organized groups, but they also made presentations and participated in debates . . . In 1910, the night school at the . . . Baptist Church presented a debate on the topic: 'Resolved: That women should not be educated equally with men.' The affirmative was presented by two men, but Emma Simmons and Emma March presented the negative . . . the women won the decision." (Quote from the *Monroe County News*, July 5, 1983; photograph courtesy John Jacobs.)

UNIDENTIFIED WOMAN, PHOTOGRAPH INSCRIBED "FROM MINNIE (?) COOKE TO MRS. WALTER COOKE." "Sometime in Buxton's early history, black women organized a chapter of the Federated Black Women's Club of America. In April, 1907, the latter group and the Ladies Industrial Club passed resolutions approving the efforts of the Buxton Ministerial Alliance to close the saloons on the outskirts of Buxton." (Quote from the *Monroe County News*, July 5, 1983; photograph courtesy SHSI-DSM.)

MASONIC LODGE OFFICERS, C. 1910. Jonathan Roach (left) and Andrew McDowell (right) are pictured here. "There were lodges. We had the Masonic Lodge, I remember particularly because my father belonged to that. And it depended on who you were whether you'd be accepted or not. If you were black-balled and it was known over town that you were black-balled . . . that was about the worst thing that could happen to you." (Quote by Marjorie Brown, African American resident, oral history, 1980; photograph courtesy SHSI-DSM.)

"Boy Evangelist." "At a revival we used to have, I remember this little boy was preaching. He used to wear a little white robe, and he was preaching. He ran our revival, and that's when I joined the church . . . Loney Lawrence Dennis was his name." (Quote by Gertrude Stokes, African American resident, oral history, 1981; photograph courtesy SHSI-DSM.)

THE BROWN FAMILY, C. 1910. Mr. and Mrs. Horace Brown, Horace Jr., and James are all pictured in this photograph taken around 1910. "Family times [were] where we would sit down and talk about it [slavery]. So the family life in Buxton was a life different from when they [grandparents] were young, as slaves. So I'd say Buxton was a place, was heaven." (Quote by Hazel Stapleton, African American resident, oral history, 1980; photograph courtesy SHSI-DSM.)

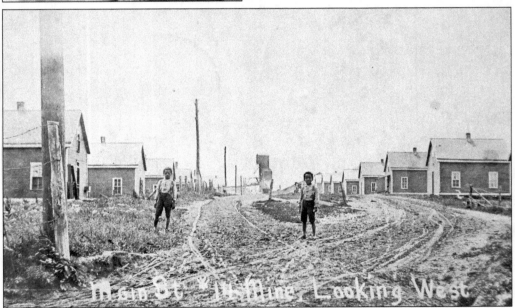

"MAIN ST #14 MINE, LOOKING WEST." "If we were at another person's house like the Beamans—we were awfully close together all our lives—and if we were over there playing and done wrong, Ms. Beaman would whip us, send us home. And she told us to tell mama what she whipped us for. We told her, we'd get another whipping . . . Mama was strict that way, she was awfully strict. She never spared the rod at all. Thank God that she didn't." (Quote by Oliver Burkett, African American resident, oral history, 1980; photograph courtesy John Jacobs.)

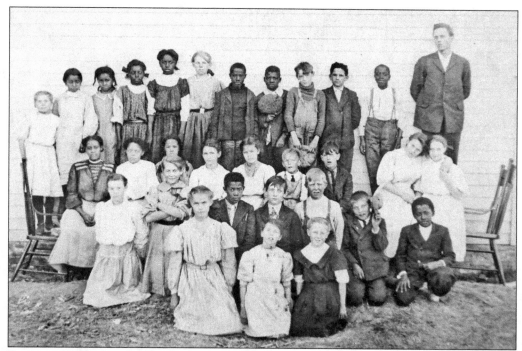

Seventh Grade Class in Buxton. "We did get a good education . . . You knew you was in school in Buxton. You said 'yes ma'am', 'no ma'am', 'yes sir', 'no sir,' and 'I'm sorry' and all that stuff, do your own work and study when you were in school. Sat there like a bunch of damn zombies. No whispering, no playing, none of that stuff. Well, the biggest thing that they taught was reading, writing, arithmetic, a lot of history, geography, a lot of religion." (Quote by Charles Taylor, African American resident, oral history, 1980; photograph courtesy of a private collection.)

Buxton Schoolchildren. "They rented the school [Eleventh Street School] for us Slavish kids to learn at in the summer . . . We learned catechism and stuff . . . It was all Slovak [language]." (Quote by Joe Rebarchak, Caucasian resident, oral history, 1981; photograph courtesy John Jacobs.)

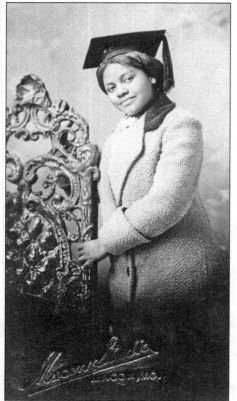

SWEDISH SCHOOL. "In school, everybody was treated alike . . . And they didn't care what color you was. If you needed directing, you better believe that you got it. And everybody got their lessons exactly like they told 'em to. They didn't make no difference in 'em. At all." (Quote by Nellie King, Caucasian resident, oral history, 1980; photograph courtesy John Jacobs.)

THELMA SHELTON. "I guess, just like it is today, if you had parents who cooperate with the school and the children would cooperate with the school, the child could acquire a very nice education. We had some intelligent and very smart children and then in a class, in some classes, now, we'd have all size children. When I was teaching second and third grade, some of the third graders were old as me." (Quote by Lola Reeves, African American resident, oral history, 1980; photograph courtesy SHSI-IC.)

BOOKER T. WASHINGTON, 1905. "We had good programs. We had the days of Booker T. Washington. We had him there [YMCA] and all the famous people at that time, I can't even remember." (Quote by Vaeletta Fields, African American resident, oral history, 1981) "In 1902 Buxton entertained Booker T. Washington at the Opera House . . . Hundreds were turned away because of lack of room in the opera house." (Quote from the *Monroe County News*, September 1, 1993; photograph courtesy SHSI-DSM.)

THE *BUXTON GAZETTE*, JULY 2, 1908. "Prof. A. R. Jackson, who is the leader of the Buxton Famous Band of 36 pieces. He is also one of the promoters and managers of the Buxton Gazette, the only other colored journal published in Iowa, except the Iowa State Bystander." (Quote from the *Iowa State Bystander*, August 19, 1904; photograph courtesy Michael W. Lemberger.)

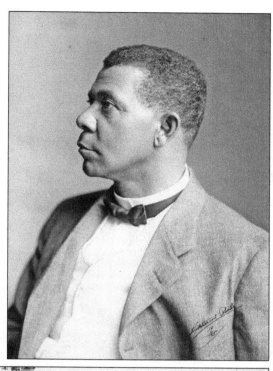

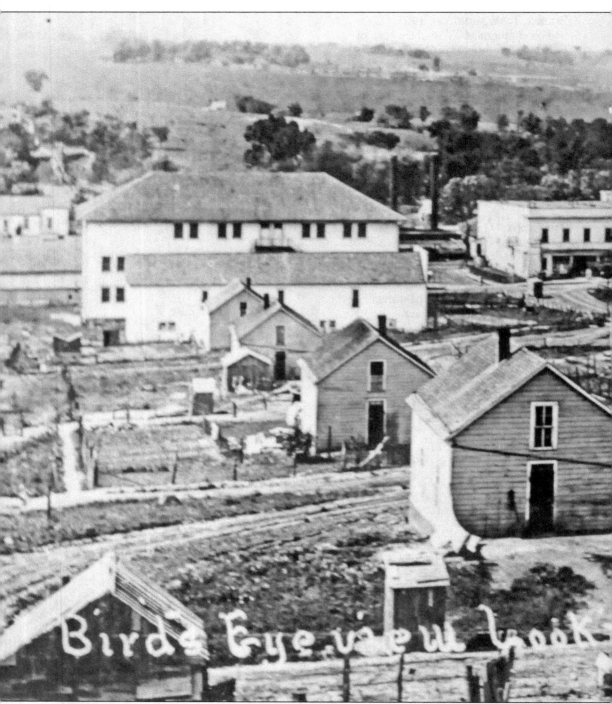

Bird's Eye view book

VIEW FROM WATER TOWER LOOKING NORTH. The YMCA is pictured at back left. "Yep, I joined it [YMCA]. It was 50 cents a month . . . The YMCA was three stories high. They had the pool hall, the reading room, the recreation room downstairs. Upstairs they had the movie hall, and up on the third floor was the lodge, where they had the lodge meetings and things, you know what I mean? Then

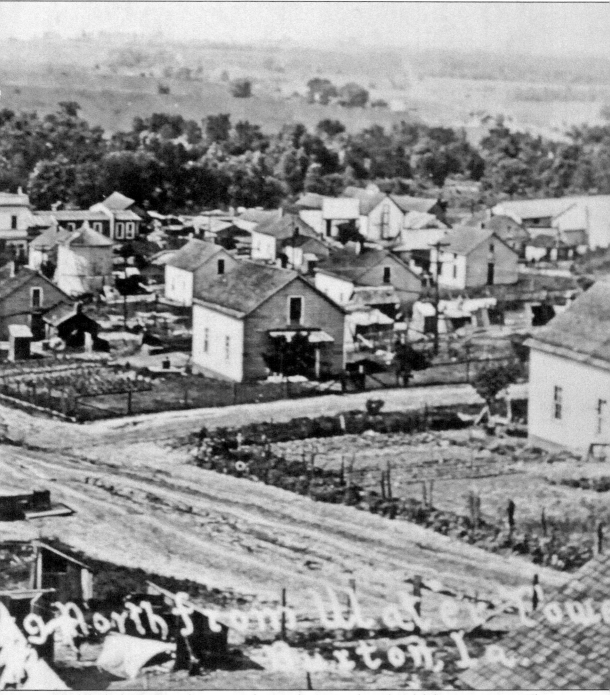

we had the little YMCA right across, right next door to it, where they did the swimming . . . They had skating, roller skating. They had that in there, upstairs [in the] little Y . . . They had dances in there 'cause my cousin Leola used to play piana for the orchestra." (Quote by Elmer Buford, African American resident, oral history, 1980; photograph courtesy Michael W. Lemberger.)

BUXTON OFFICES. "They used to get checks . . . $1 . . . $2 to $5 . . . and we'd go there [to the company store] and buy what we wanted and they'd clip that off on the check 'cause they had an office there. You'd go and get your check from Ms. Christian and Ms. Helen. Ms. Helen was Mr. Buxton's sister and Ms. Christian was her cousin, and we'd go there and get our check and then we would go to the store and buy what we wanted and they would punch it out on the check . . . Those checks would come off the miner's statement. His statement, they'd check it off." (Quote by Gertrude Stokes, African American resident, oral history, 1981; both, photograph courtesy MCHS&M.)

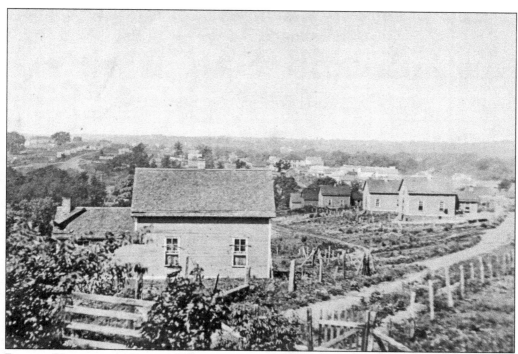

BUXTON HOUSES WITH FENCED YARD.
"There wasn't as much canned goods as there are now. You didn't open a can and throw it out. In other words, there wasn't no garbage problem because very few people had canned goods and what cans they had they put in the outside toilet. When it filled up, they'd just dig another toilet hole." (Quote by Carl Kietzman, Caucasian resident, oral history, 1981; photograph SHSI-DSM.)

MEN WITH DOG, C. 1910. "Well, everybody had dogs and things. You didn't have much trouble with leftover food." (Quote by Nellie King, Caucasian resident, oral history, 1980; photograph courtesy SHSI-DSM.)

ADVERTISEMENT IN *BUXTON GAZETTE,* 1908. "They'd deliver meat every day . . . Now they had what we call a meat wagon and . . . they had these Indian ponies that they drove . . . they'd deliver it the next morning, the fresh meat, killed the day before or the night before, it was all fresh meat, pork and beef . . . me and my dad, we done a lot of butchering for them, too." (Quote by Archie Allison, Caucasian resident, oral history, 1981; photograph courtesy Michael W. Lemberger.)

PEOPLE PICKING CROPS IN BUXTON OR ALBIA. "My father, he rented 20 acres out there from Buxton. You see, it was quite a few neighbors had acreage out from Buxton . . . They [parents] bought a little four-room house from Lost Creek, Ioway, and had it moved out there . . . we had our horses and I'd drive down with her [mother] and sell vegetables to people in Buxton. I'd go up the road, and they'd come to the wagon and buy what they wanted—green beans, peas, and different things what we had." (Quote by Gertrude Stokes, African American resident, oral history, 1981; photograph courtesy SHSI-DSM.)

WOMEN AND MAN EATING WATERMELON. These people eating watermelon were most likely in Stark, Iowa, or near Buxton. "Buxton was a good market for apples, pears, peaches, plums, grapes. Anything that the farmer had he wanted to sell all he had to do was go to Buxton with his wagon team in a wagon or buggy and he could sell anything." (Quote by Walter Gardner, Caucasian, lived near Buxton, oral history, 1981; both, photograph courtesy SHSI-IC.)

HOUSE IN BUXTON. "If somebody wanted me to do wash or something, I would. People worked by the day, you know . . . You'd go to somebody's house and work all day long. Do you know how much you'd get? . . . One dollar." (Quote by Nellie King, Caucasian resident, oral history, 1980; photograph courtesy SHSI-IC.)

MEN ON PORCH OF DR. E.A. CARTER'S OFFICE. Pictured are, from left to right, Jim Warren, Dr. Carter's brother-in-law; Dr. E.A. Carter; Dr. Powell; and Dr. Gray with Duke, the dog. "They called them company doctors. Now there most of the miners, they'd sign up for doctors. You paid, like for a family, it was $2. Single person was $1 a month. That's what you paid, and it was checked off." (Quote by Jacob Brown, African American resident, oral history, 1980; photograph courtesy SHSI-DSM.)

ALICE, WILL, MARTHA, AND WILLIAM CUZZENS IN FRONT OF HOME, C. 1910. "We had midwives, and it was much better for you, too, because they'd take care of your kid for nine days, wash him up and everything and clean him up for you and everything, show you how to, learn you how to keep him, you know, and everything and they didn't charge you but $5 or something . . . I stayed in the bed. See they don't allow you out in them days. You didn't get up under a month. You couldn't come outdoors—you could get up, but you couldn't go outdoors for a month." (Quote by Susie Robinson, African American resident, oral history, 1981; photograph courtesy SHSI-DSM.)

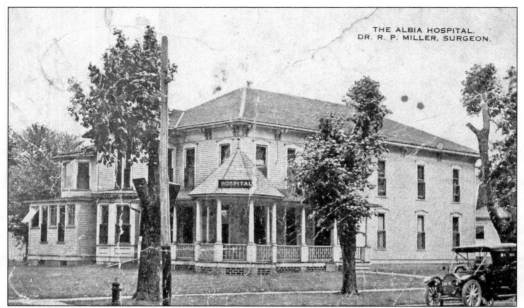

MINERS HOSPITAL IN ALBIA. Previously, this hospital was a boardinghouse owned by Dr. Robert P. Miller. "If you was married and had a family, it cost you $2 a month to belong to the hospital in Albia. Dr. Gutch had a hospital, and it didn't make any difference what kind of operation you wanted, it didn't cost you any more." (Quote by Clyde Wright, African American resident, oral history, 1981; photograph courtesy MCHS&M.)

BARNEY THOMAS IN THOMAS DRUG. "The remedies [for colds]: camphor and, ah, I think . . . kerosene, lard, and turpentine. Now she [mother] would mix them all together and she'd heat them on the back of the stove. Then, she'd get a piece of flannel . . . she would use a big pie tin . . . and she would soak, saturate this flannel and put it on his chest and his back." (Quote by Jeanette Adams, African American resident, oral history, 1980; photograph courtesy John Jacobs.)

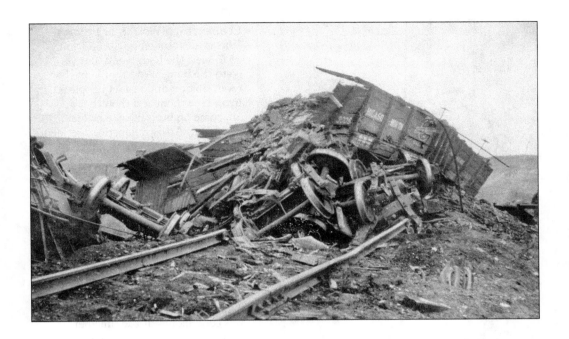

TRAIN WRECK NEAR BUXTON. "A big train accident they had there [Buxton] . . . the coal train had stopped, see. They had about 10 or 12 cars of coal and the train that was coming from the junction was the water train had three, ah, three flats of water—they carried water then—and when they hit this train, of course the coal train couldn't expand, and the water train hit it and they both just bounced up like that." (Quote by Hazel Stapleton, African American resident, oral history, 1980; both, photograph courtesy SHSI-IC.)

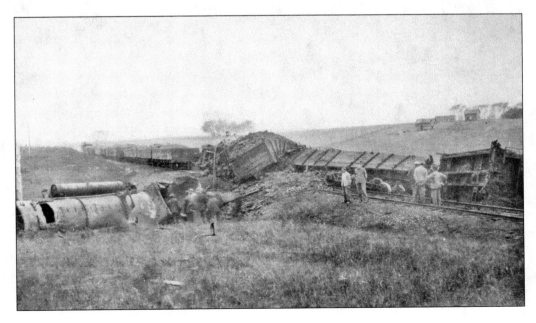

UNIDENTIFIED WOMAN IN FUNERAL WREATH. "If someone die and you go to view the body, you'd always go to the home. And they kept that room shut off and just let people go in and see them and then they'd, ah, come on out." (Quote by Hazel Stapleton, African American resident, oral history, 1980; photograph courtesy of a private collection.)

RUBBLE IN MINE SHAFT AFTER BLAST. "The company, after he [husband] got killed, well they gave me so much money. I got $4,000 but that was good money at the time but they didn't give it to me all at once. They just paid me monthly . . . they supposed to take care of you if your husband got killed in the mine." (Quote by Susie Robinson, African American resident, oral history, 1981; photography courtesy SHSI-DSM.)

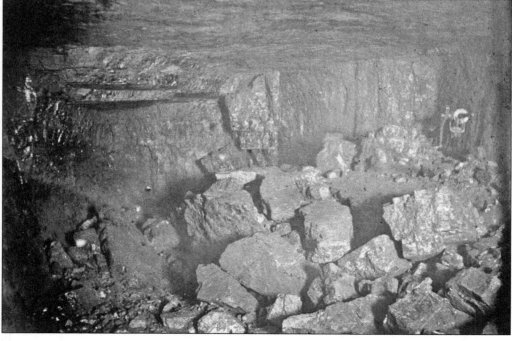

FUNERAL PROCESSION IN BUXTON. "I remember a man name Jenkins . . . a black man . . . and he always rode this horse in the procession and he would always be ahead of the band when the lodges would turn out [parade] or either when they would have a funeral and the band would be playing and this horse would be just prancing from side to the other and he had on this high hat with this big plume in it and everything. (Quote by Naomi Ampey, Buxton resident, oral history, 1981; photograph courtesy John Jacobs.)

PARADE IN BUXTON. "July 4th was a day long to be remembered in Buxton. Work was laid aside . . . long before the appointed hour, 1:30 p.m. the line was formed in front of the Y.M.C.A. headed by the famous Buxton band of thirty pieces. All of the business organizations of Buxton the Y.M.C.A. and the Sabbath Schools were represented in the parade through the streets of Buxton thence to the park." (Quote from the *Iowa State Bystander*, July 12, 1907; photograph courtesy John Jacobs.)

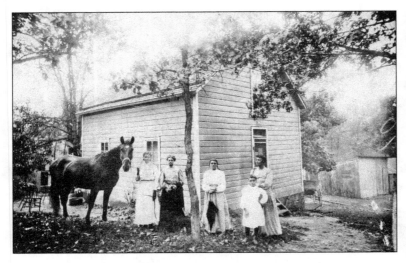

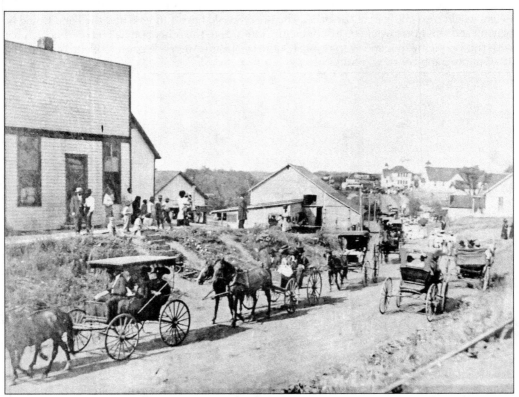

NORTHERN ENTRY INTO BUXTON. "They had hacks when you were going out of town, going to Albia. Going to Hamilton, why, they had . . . they used to call them rigs. But no transportation in town. I think everybody, you used to have to walk . . . oh, yes, they had horse and buggies. Yes, lots of people had horse and buggies." (Quote by Hazel Stapleton, African American resident, oral history, 1980; photograph courtesy John Jacobs.)

DOWNTOWN ALBIA, C. 1912. "We had a horse and a two-seated carriage. She [mother] used to carry passengers backward and forward from Albia, backward and forward, wherever they wanted to go." (Quote by Gertrude Stokes, African American resident, oral history, 1981; photograph courtesy MCHS&M.)

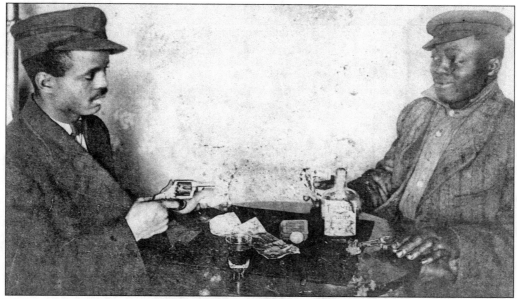

MEN GAMBLING. "It's always burnt me up the town had such a hard name; didn't deserve it. It didn't deserve it. I was over in Illinois, my wife and I went over there. We met a lady and she asked us where we was from and we was from Ioway and oh, from what part. 'Oh, around Albia.' She wanted to know where we lived, and we said, 'Close to Buxton.' 'Oh, that's the town you go through with a gun in each hand and a knife in your teeth.' Now, where in the hell did you get that idea?" (Quote by Carl Kietzman, Caucasian resident, oral history, 1981; photograph courtesy SHSI-IC.)

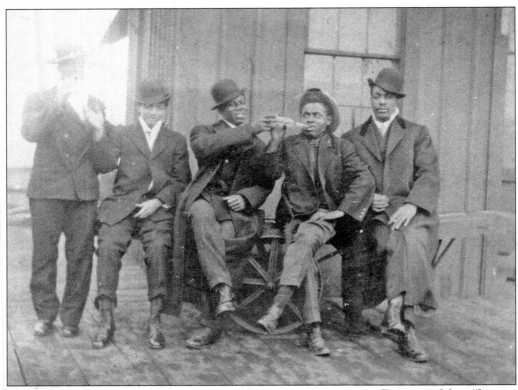

DRINKING MEN. "I owned two houses right close together. I took the partition out of one house and bought a pool table, put up a pool table, and on weekends, I'd run a card game . . . I never dealt in any liquor . . . Yeah, there was a lot of bootlegging going on [men could bring their own liquor] . . . Start the card game right after the payday and it would run 'til Monday morning when the mine opened up again . . . any nationality . . . they were all there. Just like one big happy family." (Quote by Lou Walraven, Caucasian resident, oral history, 1982; both, photograph courtesy SHSI-IC.)

Five

TOGETHER, IN HARMONY

African Americans were the majority until 1910 and continued to be the largest ethnic group until 1915, accounting for approximately 40 percent of the population. During the same time, foreign-born people—such as Swedes, Slovaks, people from the British Isles, and some Italians—made up 7 percent to 14 percent, with Caucasian Americans making up the difference. As previously mentioned, public life between all races/ethnicities was integrated. Families lived next door to each other, children shared classrooms, and adults worked together and shopped at the company store, patronized various businesses throughout the town, and attended certain public events, such as Buxton Wonders games. On these things, the black and white residents who were interviewed agreed.

Many interviewees could recall and matter-of-factly state at least one interracial marriage, with Oliver Burkett, an African American resident, going as far to say, "There were a lot of interracial marriages down there . . . There was Charlie King, he was a black man, he married a white woman. Hobe Armstrong, he was a black man and he married a white woman. George Morrison, he was married to a white woman. There were a lot of others but I don't remember their names but those I do remember."

They also agreed that some things were segregated. For example, blacks and whites attended separate churches. East Swede Town and West Swede Town were predominantly white. And while everyone attended movies together at the YMCA and whites sometimes used the meeting rooms or the auditorium, where Catholic church services were also held, the YMCA was mainly the domain of African Americans.

The opinions varied on some things, such as dances. Some former residents said that African Americans and Caucasians had separate dances, while a few others stated they attended the same ones. When an interviewer stated that there seemed to be a color line when it came to dances, Ada Morgan, daughter of E.M. Baysoar, who was the company's general superintendent from 1909 to 1913, disagreed. She implied it was by choice, saying, "I doubt that the colored wanted to go there [white dances]."

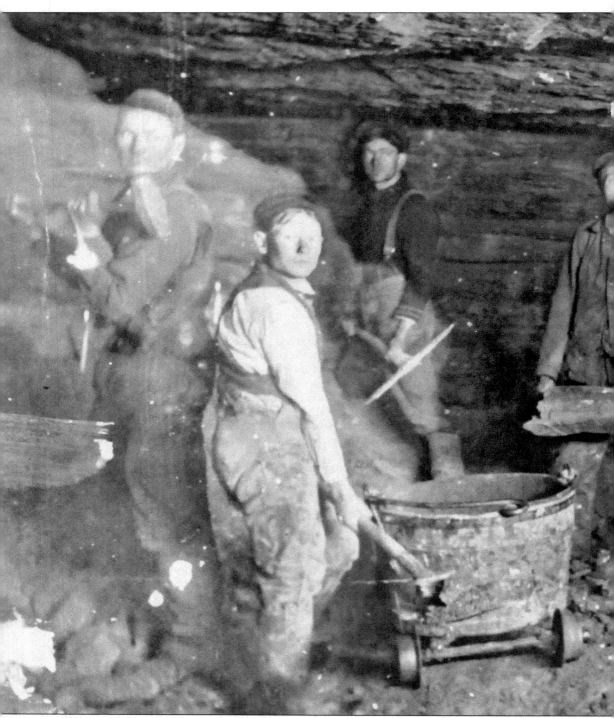

GROUP OF MINERS IN BUXTON MINE. "When I was young, I didn't give it a thought, really. Had everything, just like the black had everything, white people were the same way. They had everything they wanted. They had their socials and they had their dances and went places, made

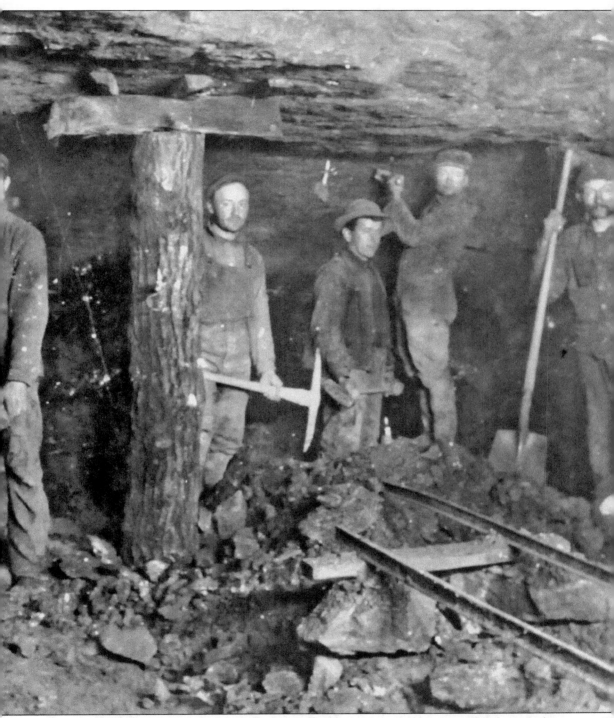

money, spent money." (Quote by Archie Harris, Caucasian resident, oral history, 1980; photography courtesy Michael W. Lemberger.)

LEONARD WALKER (RIGHT) AND BROTHER, ACCORDING TO HERMAN BROOKS. "He [dad] rode the miner's train to [mine number] 18, which is probably 15 miles southwest of Buxton. He rode there with the blacks. There were probably four blacks to one white in the miners' train. There was never any trouble." (Quote by Harvey Lewis, Caucasian resident, oral history, 1980; photograph courtesy SHSI-DSM.)

DOCTORS WITH DR. E.A. CARTER (CENTER). "A negro doctor attended my mother when my brother was born . . . which again indicates to me there was no prejudice there." (Quote by Sister Maurine Sofranko, Caucasian resident, oral history, 1981; photograph courtesy SHSI-DSM.)

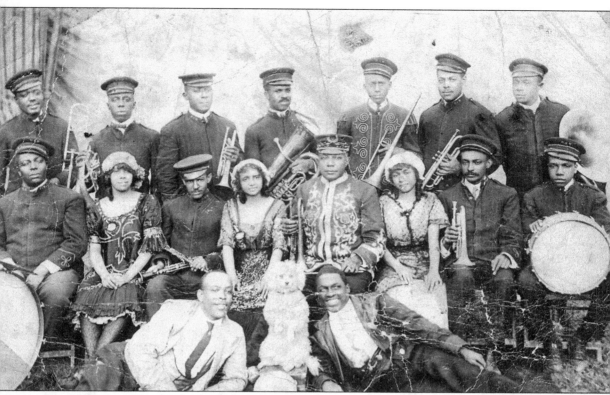

BUXTON BAND. "I've watched the black dances but I never went in and I was never invited in but I have went to the door and looked in because they had some of the best gosh darn orchestras that you ever heard . . . They had a band in Buxton that couldn't be beat." (Quote by Archie Allison, Caucasian resident, oral history, 1981; photograph courtesy AAMI.)

BLUFF CREEK. "We [blacks and whites] went to school together, we played together, we swim together, and back in those days, we swim just like we come in the world, swim in the nude. That's the way we'd do. All the girls would turn their back 'til we'd get in. We'd turn our back 'til they get in. That's the way we used to do it." (Quote by Hucey Hart, African American resident, oral history, 1980; photograph courtesy John Jacobs.)

BUXTON MINING COLONY CONSTITUTION AND BYLAWS. "There are two colonies. First is the Buxton Mining Colony. Mr. W. W. Jones is president; A. C. Harris, vice president; J. T. Romans, secretary; N. P. Herrington (white), treasurer; and the Mutual Benefit Association, composed of white employees: President, Chas. Isaacson; secretary, G. N. Kitzmiller; treasurer, N. P. Herrington." (Quote from the *Iowa State Bystander*, December 6, 1907; photograph courtesy John Jacobs.)

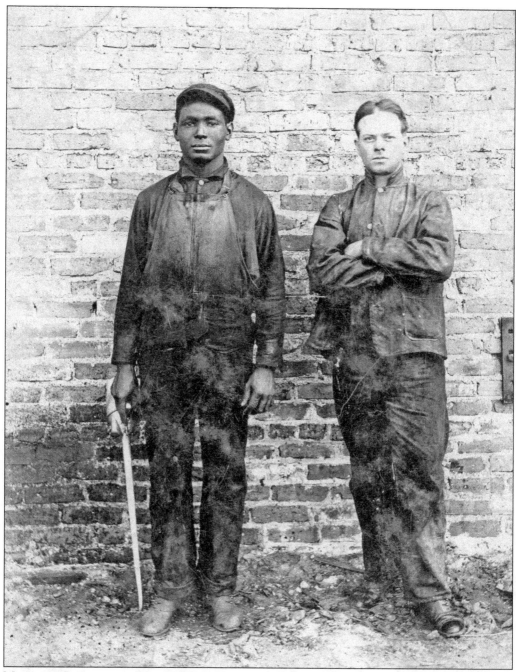

MINERS OR BLACKSMITHS, C. 1910. "But now we gambled together, us men, but, ah, dance—whites had their dances and the blacks had their dances. It wasn't no problem at all but they just, you know [didn't mix]." (Quote by Archie Harris, Caucasian resident, oral history, 1981.) "If my brother was living, Mike, he'd tell you about them [saloons] . . . He used to go down there, dance with the colored guys and everything, women." (Quote by Joe Rebarchak, Caucasian resident, oral history, 1981; photograph courtesy SHSI-DSM.)

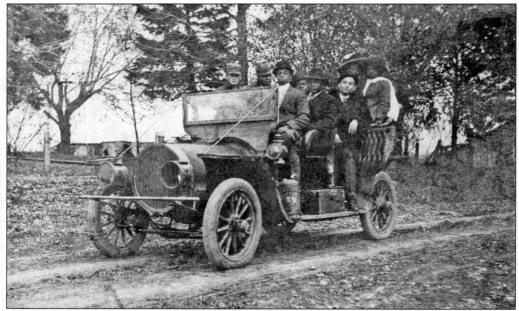

GROUP ON OUTING IN REO AUTOMOBILE. "Well, it [Buxton] seems like a place that you wouldn't want to live—we wouldn't want to live. Didn't seem like the town was clean or kept up. There was lots of children. There was lot of dogs, there was lots of pets running over the place . . . [lots of kids] in the yards and around, mostly colored." (Quote by Walter Gardner, Caucasian, lived near Buxton, oral history, 1981; photograph courtesy SHSI-DSM.)

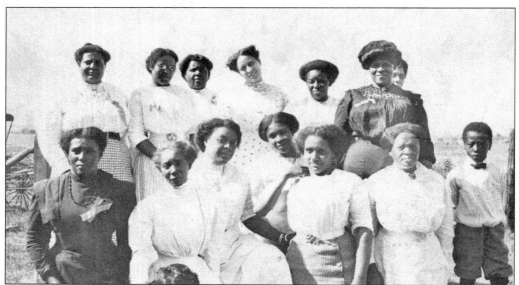

BUXTON WOMEN WITH ROSE WARREN CARTER (SECOND ROW, CENTER), C. 1910. "The white and the colored, you know, Mama had both friends . . . Ladies would come over and visit . . . The women would put a quilt in a frame and they'd all, I guess, the neighbor friends would come in and they'd quilt that quilt . . . and the kids would have to thread the needles." (Quote by Dorothy Collier, African American resident, oral history, 1980; photograph courtesy SHSI-DSM.)

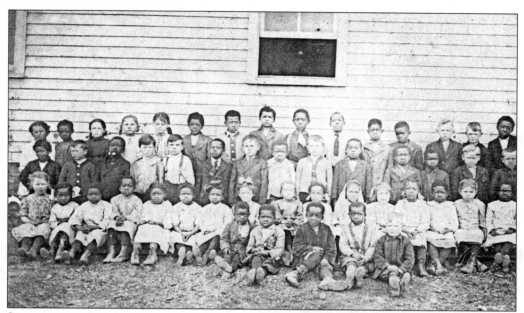

SCHOOLCHILDREN IN BUXTON. "I went to a school that was practically all black . . . The instruction I thought were very good. I had a black teacher. I think her name was Mrs. Blackburn . . . She was an excellent teacher." (Quote by Charles Lenger, Caucasian resident, oral history, 1981; photograph courtesy AAMI.)

DR. E.A. CARTER AND SARAH TOSWELL WARREN, MOTHER-IN-LAW. "You take some white people that have never lived around colored, it was kind of hard for them 'cause they'd been used to doing everything they wanted to do and didn't give the colored people a chance. Well, them kind of people didn't need to be there 'cause they couldn't live there very long 'cause they'd [Buxton/company] fix it so they wouldn't be there . . . They'd make it hard for them 'til they'd move away from there." (Quote by Bessie Lewis, African American resident, oral history, 1981; photograph courtesy SHSI-DSM.)

BUXTON SUPERINTENDENT'S HOUSE. "I don't know just when he [Ben Buxton] left but my father [was superintendent] in the summer of 1909 . . . Well, I enjoyed the few people that we became acquainted with. Some of the men in the office . . . there was a woman in the office, we were good friends . . . [No, I didn't know any black families but] I didn't know any white miners' families, either. That meadow seemed to separate us." (Quote by Ada Baysoar Morgan, Caucasian resident, oral history, 1981; photograph courtesy SHSI-DSM.)

MRS. LEROY TUCKER, C. 1910. "I had been raised in a white surrounding. Going to Buxton with all the people of my own race was a great experience . . . I learned a lot and I acted shy and timid first. But after I got there, I could exercise my feelings, my potentials, my talent, and my social life, and I think Buxton brought a whole lot of joy to me, just to be able to live and, a colored girl, in a colored area and feeling like I was one of them and I was happy." (Quote by Lola Reeves, African American resident, oral history, 1981; photograph courtesy SHSI-DSM.)

Six

LIFE AFTER BUXTON

Misfortune hit Buxton in 1914 when the demand for coal declined. Miners were laid off. The Consolidation Coal Company began relocating miners to its Mine No. 18 in Consol, approximately 18 miles southwest of Buxton. By 1915, of the 4,598 Buxton residents, African Americans were no longer the ethnic majority.

By 1918, the mines near Buxton were almost completely played out. The Consolidation Coal Company expanded operations at Consol and readied the opening of Mine No. 19 at Bucknell (also known as Haydock). By 1919, with only 400 or so residents left, Buxton was well on its way to becoming the ghost town of today.

From 1919 to 1921, Consolidation continued to move miners—and houses— to the new mines. Excess houses were sold to the public for between $100 and $125. By 1922, there were no miners living in Buxton.

Believing that coal operations would be successful, Consolidation moved its headquarters from Buxton to Haydock in 1923. More houses were built. Trees were planted. Prominent businessmen from Buxton, such as Louis Reasby, C.W. Armstrong (Hobe Armstrong's son), and Reuben Gaines Jr., opened businesses. As Haydock grew, its businesses included a company store, a drugstore, a bakery, and pool halls, as well as grade schools, a three-story high school, and seven churches.

Though former residents guessed its population to be around 6,000, it never matched the social outlets of Buxton.

"Everybody was sick when Buxton went down," said Susie Robinson, former Buxton resident, "everybody was sad. When we went to Haydock, it wasn't the same."

Haydock's lifespan was even shorter than Buxton's. In 1925, for unknown reasons—perhaps because of higher tax assessments—Consolidation sold out to Superior Coal Company. Within two years, the continuing decline in coal demand and the negative perception of Iowa coal, plus labor problems, forced Superior to shut down Mine No. 18 and Mine No. 19.

Haydock, like Muchy, Buxton, and Consol, became a ghost town.

BUXTON GREETING CARD. "It's no place ever going to be like Buxton. That's the best place that I've ever been, Buxton . . . that's where everybody lived happy, in Buxton . . . Buxton was one of the best places in the United States, Buxton was." (Quote by Susie Robinson, African American resident, oral history, 1981; photograph courtesy AAMI.)

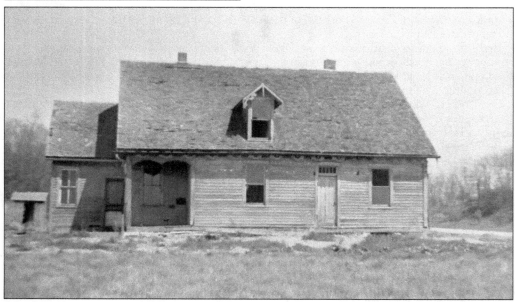

HOBE ARMSTRONG HOUSE, UNDATED. "H.A. Armstrong Dead at Buxton. . . Hobe was one of the largest landowners in southern Iowa, holding more than 1,600 acres of land . . . Not only did Hobe establish and operate the old Muchy fair but he backed the Oskaloosa exposition with both financial and personal assistance, made possible continuation of the Albia fair . . . His race horses were to be found on almost every Iowa track and his stables included many of the fastest pacing and trotting horses this part of Iowa has ever produced." (Quote from an unidentified newspaper article clipping, probably some time after 1917; photograph courtesy of SHSI-DSM.)

CONSOLIDATION COAL COMPANY LETTER OF RECOMMENDATION. "In 1918 . . . my manager in [mine number] 18, his name was Reese and a brother to John Pete, general manager and was vice president of the coal company." (Quote by Carl Goodwin, Caucasian resident, oral history, 1981; photograph courtesy John Jacobs.)

MINE FOREMAN AND MEN IN MINE NO. 18. "We moved to Buxton 18 and that's, of course, where my dad [Louis Reasby] had this restaurant. He had nine houses over there . . . Old Cricket, we had another coal mining camp and my dad used to go buy them old houses for $50 and old Ralph Darnell used to haul them for him in an old truck, and he built them houses over there and rented them out." (Quote by Harold Reasby, African American resident, oral history, 1981; photography courtesy MCHS&M.)

CONSOLIDATION COAL COMPANY

BUXTON, IOWA,
August 25th. 1915.

TO WHOM IT MAY CONCERN:

Mr. Wm. Jones started working for us in April, 1913 as Mine Foreman at No. 15 Mine, later was Assistant at No. 16 and was finally promoted to Manager of Mine No. 18

We have found him to be a good honest, sober and trust-worthy man, he having left us on his own accord to accept a better position.

We can cheerfully recommend him to anyone desiring a man of his ability.

Yours very truly,

John P. Reese,

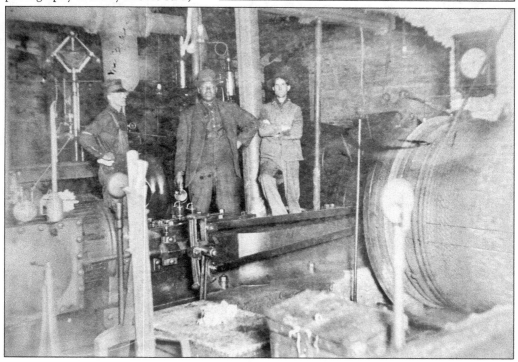

99

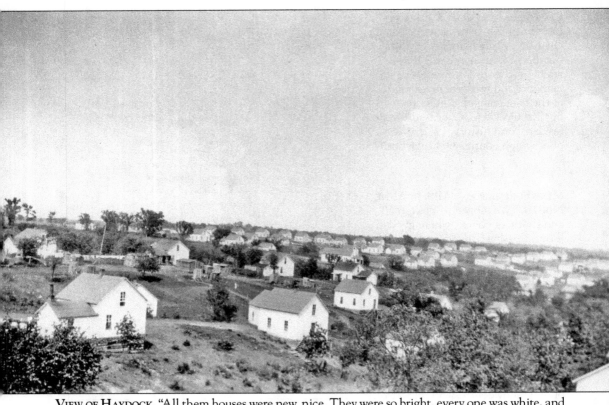

VIEW OF HAYDOCK. "All them houses were new, nice. They were so bright, every one was white, and when the sun was shining you go out to look, it just hurt your eyes 'cause everything was so white, you know . . . and them houses in Buxton was dull color, you know. Gray like." (Quote by Susie Robinson, African American resident, oral history, 1981; photograph courtesy SHSI-DSM.)

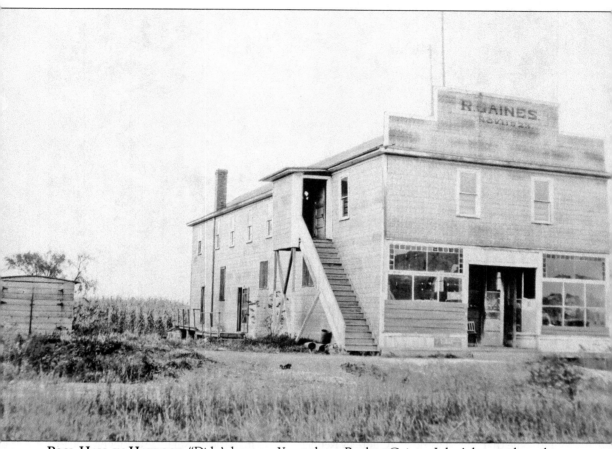

POOL HALL IN HAYDOCK. "Didn't have no Y out there. Reuben Gaines, I don't know where, he must have bought his lumber from Buxton because he built out of some old lumber . . . he had a dance hall upstairs, and downstairs was the pool hall . . . That was our recreation . . . But it wasn't nothing like old Buxton. See, you didn't have too many places to go like you did in old Buxton." (Quote by Hucey Hart, African American resident, oral history, 1980; photograph courtesy MCHS&M.)

REMAINS OF "NEGRO LODGE" IN HAYDOCK, 1935. " 'I was there when they came and I was there when they left.' Muchakinock—Buxton—Haydock. Were three ghost towns I have lived through. I was part of those communities that tried business opertunities,—some successful,—some not, and some that almost worked." (Quote by Reuben Gaines Jr., African American resident, undated memoir; photography courtesy SHSI-DSM.)

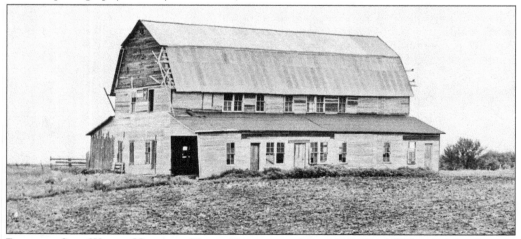

BARN ON SITE WHERE HAYDOCK HOTEL PREVIOUSLY SAT, 1935. "Paul Wilson's father bought several houses and made a hotel when they moved the houses from Buxton to Haydock . . . he had a hotel made from them houses." (Quote by Lola Reeves, African American resident, oral history, 1981; photograph courtesy SHSI-DSM.)

MINE NO. 19 AT BUCKNELL. "They [the company] had [mine number] 18 and [mine number] 19. They was going to sink 20. Then they [miners] went on strike in '27. Well, everything is right down in the mines today. They never brought out nothing on them mules. Even the men's tools is there. Thousands and thousands of dollars worth of rails, miles and miles of rails. Copper wire, motors is still down there in the mines yet. The motors that they pulled the coal with. Only thing they brought out is the mules and the men. Them mines never did open again, see?" (Quote by Archie Allison, Caucasian resident, 1981; photograph courtesy SHSI-DSM.)

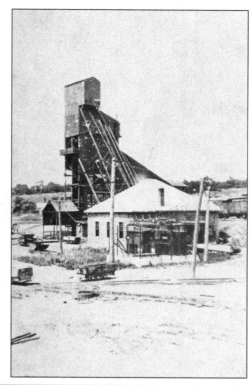

DR. E.A. AND ROSE WARREN CARTER AND THREE NEPHEWS OR SONS. "Dr. E.A. Carter, Ph. B. M. D. has moved to Detroit where he will make his future home. He leaves a host of friends who wish him well in his new field." (Quote from the *Iowa State Bystander*, February 6, 1920; photograph courtesy SHSI-DSM.)

DOWNTOWN DES MOINES. "We had everything we wanted, everything we would need [in Buxton]. I didn't know anything about segregation until I got here [Des Moines]. I didn't know what they were talking about . . . The only jobs they had [in Des Moines] was shining shoes and that kind of junk, and I didn't feel like doing none of that . . . So I went to school . . . I didn't want no part of none of that junk." (Quote by Charles Taylor, African American resident, oral history, 1980; photograph courtesy SHSI-DSM.)

BUXTON SAVINGS BANK IN BUXTON. "The Buxton bank was moved from Buxton to Bucknell." (Quote from the *Eddyville Tribune*, January 17, 1924.) "The Buxton Savings Bank of Bucknell was liquidated on Friday, October 28." (Quote from the *Eddyville Tribune*, November 3, 1927; photograph courtesy of John Jacobs.)

EBENEZER LUTHERAN CHURCH, EAST SWEDE TOWN. "Ebenezer Lutheran church at Buxton was destroyed by fire Monday afternoon. Some furnishings were saved but the blaze consumed an historic altar painting by Birger Sandzen, valued at $2,500. The Rev. Arnold H. Nelson, pastor, estimated the cost of replacing the church at more than $35,000." (Quote from the *Monroe County News*, December 23, 1954; right, photograph courtesy of SHSI-IC; below, photograph courtesy Michael W. Lemberger.)

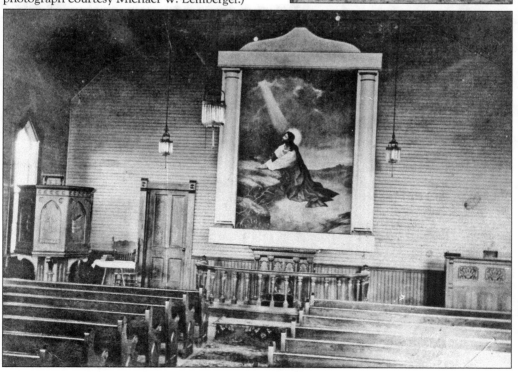

BUXTON REUNION AT SIMON BRANDT PARK, 1938. "About 4,000 persons attended the ninth annual old Buxton reunion Sunday, seven miles northeast of Lovilia. The reunion, which was held Saturday, Sunday, and Monday, attracted former residents of the old mining town. Speakers Sunday included Earl Miller of Des Moines, republican candidate for secretary of state; R.B. Hickenlooper of Cedar Rapids, republican candidate for lieutenant governor; Miss Jessie Parker of Newton, republican candidate for superintendent of public instruction; Mrs. Ruth Hollingshead of Albia, democratic candidate for congress; and John Dennison of Des Moines, state librarian.

Alf Hjort of Albia, secretary of district 13 of the United Mine Workers of America, spoke Monday delivering a labor address. Entertainment for the three-day reunion included concerts each day by the 60-piece Moravia band, shows by Hatcher players and several free acts . . . Visitors recalled the days when Buxton was a city of 5,000 inhabitants. Today there are only a few foundations of old buildings visible." (Quote from the *Ottumwa Courier*, September 6, 1938; photograph courtesy Michael W. Lemberger.)

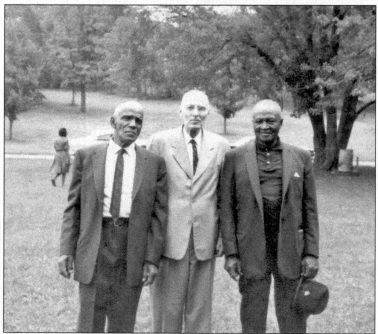

BUXTON ASSOCIATION PICNIC, 1963. "But when they had those reunions, the whites would go as well as the blacks . . . they even tried to have it in Des Moines but after awhile it begin to fizzle out, you know, and so many of the old timers had died. It didn't mean anything to the younger people like it did to us, you see." (Quote by Vaeletta Fields, African American resident, oral history, 1981; both, photograph courtesy SHSI-DSM.)

Seven

BUXTON TODAY

When Buxton died, no one thought about its historical significance. Buildings that remained were torn down, and the land was used for farmland. The largest surviving structure—the company stone warehouse—was used to store hay. It was not until 1980, when David M. Gradwohl and Nancy M. Osborn began their archeological exploration of what used to be Buxton, that interest in its preservation was born.

The downtown area of Buxton with its remaining structures—the crumbling ruins of the company stone warehouse, the office vault, and the foundations of the company store and the White House Hotel—sits on land currently owned by Jim Keegel. Keegel's grandparents on his mother's side, who were Swedish immigrants, lived in Buxton. After the town of Buxton dissolved, Emory Armstrong purchased land from the Consolidation Coal Company. In 1949, Keegel's grandmother and uncles on his father's side bought 180 acres, including the current Buxton site, from Emory Armstrong. Later, another 100 acres on the Mahaska County side were purchased, and in 1988, Keegel bought another 200 acres from Jack Harris, Buxton resident Archie Harris's son. Crops were grown, namely corn and soybeans, around the few Buxton remains.

Today, the Monroe County Historical Society and Museum keeps the grass surrounding the ruins trimmed. After 2016, crops will no longer be grown at the site for the next 10 years, for Jim Keegel has enrolled the land in the Conservation Reserve Program.

On a hillside northwest of the stone warehouse lies the Buxton Cemetery. More than 400 individuals are buried in the cemetery, but only 41 headstones remain. The cemetery is maintained by the Pioneer Cemetery Commission.

While the cemetery, the ruins, the historic marker, and the listing of the Buxton townsite in the National Register of Historic Places are the only visible reminders of Buxton, the legend of Buxton lives on in people's minds.

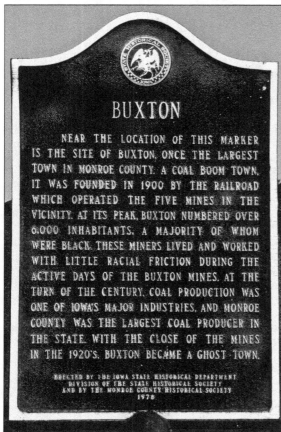

BUXTON

NEAR THE LOCATION OF THIS MARKER IS THE SITE OF BUXTON, ONCE THE LARGEST TOWN IN MONROE COUNTY. A COAL BOOM TOWN, IT WAS FOUNDED IN 1900 BY THE RAILROAD WHICH OPERATED THE FIVE MINES IN THE VICINITY. AT ITS PEAK, BUXTON NUMBERED OVER 6,000 INHABITANTS, A MAJORITY OF WHOM WERE BLACK. THESE MINERS LIVED AND WORKED WITH LITTLE RACIAL FRICTION DURING THE ACTIVE DAYS OF THE BUXTON MINES. AT THE TURN OF THE CENTURY, COAL PRODUCTION WAS ONE OF IOWA'S MAJOR INDUSTRIES, AND MONROE COUNTY WAS THE LARGEST COAL PRODUCER IN THE STATE. WITH THE CLOSE OF THE MINES IN THE 1920'S, BUXTON BECAME A GHOST TOWN.

ERECTED BY THE IOWA STATE HISTORICAL DEPARTMENT
DIVISION OF THE STATE HISTORICAL SOCIETY
AND BY THE MONROE COUNTY HISTORICAL SOCIETY
1978

BUXTON HISTORIC MARKER, LOVILIA, IOWA. "The sign was put up some time in the 70s. At that time, [through Lovilia] was the easiest way to get to the site and it was also on the highway where it was well-traveled." (Quote by Doris O'Brien, MCHS&M, 2016; both, photograph courtesy Michael W. Lemberger.)

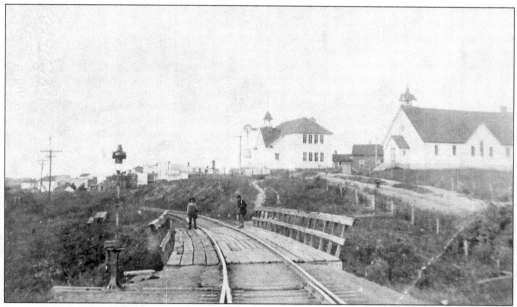

LOOKING NORTHEAST TOWARD COOPERTOWN, C. 1910. Pictured here are the First Methodist Church (center) and the St. John's AME Church (right). "Walking through Buxton makes me feel melancholy. It was no Eden, but it was ahead of its time and I can't help but wonder—if it existed today, would it still be a beacon of hope and possibility?" (Quote by Leigh Michaels, romance author and Iowa history book publisher, 2016; photograph courtesy John Jacobs.)

LOOKING NORTHEAST TOWARD COOPERTOWN, 2016. "This is where the railroad tracks would be [center]. The two churches would be up there [on the right]." (Quote by Jim Keegel, Buxton site property owner, 2016; photograph courtesy Rachelle Chase.)

First Street, Looking Southeast. "This would be all residential up here." (Quote by Jim Keegel, Buxton site property owner, 2016; photograph courtesy Rachelle Chase.)

COMPANY STONE WAREHOUSE, 1964. "A mammoth stone warehouse 162 feet long is now nearing completion, the main building, fire proof in itself, is divided into five separate compartments, each one separated by an 18 inch stone wall. The roof is to be of tile." (Quote from the *Iowa State Bystander*, November 17, 1905; photograph courtesy Michael W. Lemberger.)

COMPANY STONE WAREHOUSE, 2016. "They stored everything they brought in on the railroad car. Food, clothes, oil. Everything they sold . . . I think one room was used to store kerosene oil." (Quote by Jim Keegel, Buxton site property owner, 2016; photograph courtesy Rachelle Chase.)

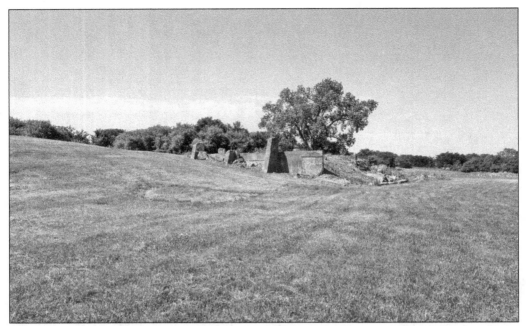

COMPANY STORE FOUNDATION, 2016. The remains of the company store (left) and the powerhouse (right) are pictured in Buxton. "Steam for heating the coal company's office and the Monroe Mercantile Co.'s is placed in both buildings from a power house situated about half way between. The electric currents for lighting are also transmitted from this power house." (Quote from the *Iowa State Bystander*, November 17, 1905; photograph courtesy Rachelle Chase.)

FOUNDATIONS, 2016. "That's the back of the company store [left] and the White House Hotel up there." (Quote by Jim Keegel, Buxton site property owner, 2016; photograph courtesy Rachelle Chase.)

Dutch Jones, 1964 (Above) and Warehouse Side View, 2016 (Below). "You could walk between the railroad track and the company store, they were that close." (Quote by Elmer Buford, African American resident, oral history, 1981; above, photograph courtesy Michael W. Lemberger.; below, photograph courtesy of Rachelle Chase.)

DISPLAY CASE FROM COMPANY STORE, 2008.
"There was a men's shop, Williams Clothing Store, on the west side of the square in Albia and we got it [display case] from them when they closed. His [owner's] father got it from Buxton years ago." (Quote by Doris O'Brien, MCHS&M; photograph courtesy Michael W. Lemberger.)

BELL FROM LUTHERAN CHURCH. "The bell initially ended up at the Nelson Pioneer Center in Mahaska County. They asked us if we wanted it and we said yes. I don't know how they got it here." (Quote by Doris O'Brien, MCHS&M, 2016; photograph courtesy Michael W. Lemberger.)

OFFICE VAULT REMAINS, 1968 (RIGHT) AND 2016 (BELOW). At right, Dutch Jones, a Buxton resident, sits in front of the remains of the office vault. "The coal company moved its general offices from Muchakinock to Buxton August 26, 1901, and has an office building in Buxton. It was built especially for the purpose, is isolated from the rest of the buildings, has electric light and a fine large brick vault for the safe keeping of the records and papers of the company. The office rooms, four in number, are neatly and comfortably furnished." (Quote from the *Iowa State Bystander*, November 17, 1905; right, photograph courtesy Michael W. Lemberger; below, photograph courtesy Rachelle Chase.)

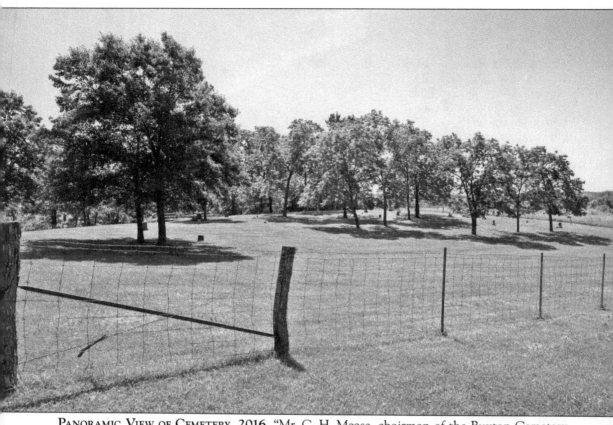

Panoramic View of Cemetery, 2016. "Mr. C. H. Mease, chairman of the Buxton Cemetery association, called a mass meeting at the Y. last week for the purpose of arranging a program for Decoration Day. Some very good suggestions were made toward the improving and keeping up of our home cemetery." (Quote from the *Iowa State Bystander*, June 8, 1917; photograph courtesy Rachelle Chase.)

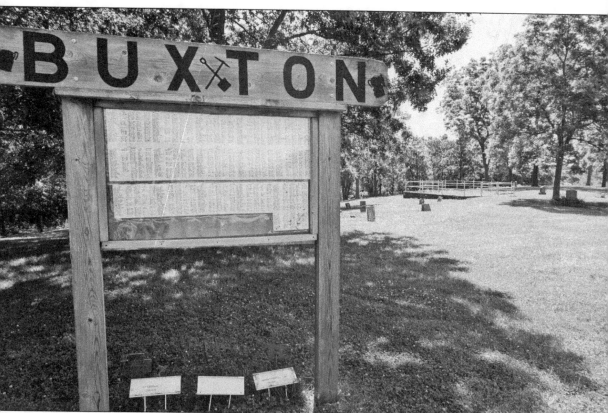

BUXTON CEMETERY SIGN, 2016. "I searched death records from Monroe and Mahaska, County [to create burial list]. Some I got from Mahaska County funeral records. I may have gotten a few from family members. Me and my husband, Dan—and Floyd Hall, he cleared out trees and brush—we helped with cleanup of brush and debris . . . It took pretty much all summer, starting in the spring and into the summer until some point, 10 years or more ago." (Quote by LeeAnn Dickey, Buxton genealogist, 2016; photograph courtesy Rachelle Chase.)

LOUIS REASBY HEADSTONE, 2016. "A lot of headstones were cleaned by Rosalie's husband, Jim . . . The Pioneer Cemetery Commission—Rosalie Mullinix and I were founders of the commission—takes care of 30 some cemeteries in Monroe County, including this one." (Quote by LeeAnn Dickey, Buxton genealogist, 2016; photograph courtesy Rachelle Chase.)

GAINES FAMILY BURIAL PLOT, 2016. "My father's grave is still there and my sister . . . if you've been up to the cemetery, there's one got a railing around it up there. That's our cemetery, our plot . . . Yeah, my father was there and my sister was there and some of my sister's kids were buried there. So we went down and cut the trees down. We go down there every year and decorate anyway. And we put some of this stuff down to kill the trees and so they won't come back in the fall . . . No, he [Reuben Gaines Jr.] was buried in Albia." (Quote by Donald Gaines, African American resident, oral history, 1981; photograph courtesy Rachelle Chase.)

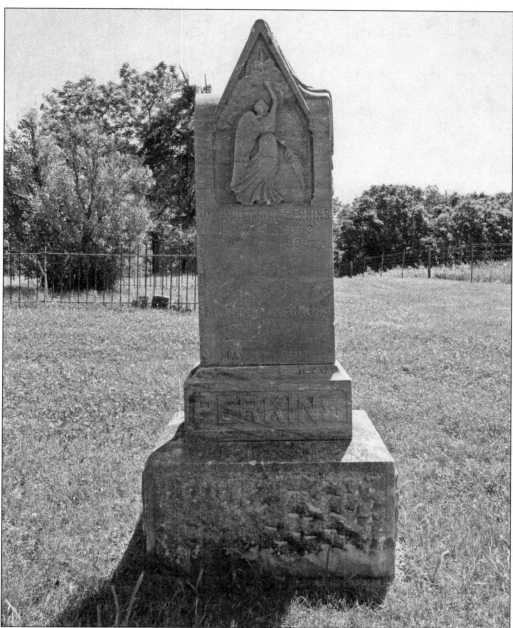

W. Anderson Perkins Headstone, 2016. "Mr. Wm. Anderson Perkins and wife, came to the state of Iowa in October, 1880, bringing the little boy Lewis, who was then 3 years old . . . These early years were spent in Muchakinock during the days when that section was on the boom. The father made a deal of money as the muost [sic] up-to-date hotel keeper in the town . . . the father invested a part of his money in a private coal mine, which was known as Perkins & Son . . . This venture was a success, as were all the father's undertakings. He never knew the word "fail." When Buxton opened up in 1900, Perkins & Son built the first hotel and added materially to their possessions already acquired through former investments." (Quote from the *Iowa State Bystander*, December 20, 1918; photograph courtesy Rachelle Chase.)

JIM KEEGEL BY UNIDENTIFIED PLOT. "I had three sisters—one was from Colorado, one was from Maryland, and one lived in Des Moines—who had family in Buxton here. It's amazing to see how happy you can make them by showing them some old buildings and graves. That's the part I enjoy. I know there's a lot of history, but it is the personal part that I enjoy." (Quote by Jim Keegel, Buxton site property owner, 2016; photograph courtesy Rachelle Chase.)

Eight

UTOPIA?

The Buxton experience seemed to be different for Caucasian and African American residents. While most Caucasian residents interviewed viewed Buxton as a good place to place to live and felt they were treated fairly, its demise was not viewed with the same level of emotion experienced by the African American residents. Nearly all African American residents who were interviewed spoke positively and nostalgically about Buxton, ranking it as one of the best—if not the best—places they had ever lived. From the tone of their voices, from the words they used, it sounded like it could have been utopia.

Some people seem confused—or perhaps annoyed—by this viewpoint. Doris O'Brien of the Monroe County Historical Society & Museum stated, "In actuality, Buxton was ahead of its time. It is a shame it's gone. It should be one of the best-known coal mining towns in the state. It didn't last. It's gone but not forgotten." And then added, "The thing is, everybody has heard about how wonderful Buxton is. They've turned it into a myth. Well, we're dealing with reality." The reality being the gambling and the murders reported in the papers.

As previously stated, Buxton was not perfect. Nearly all residents interviewed agreed there was gambling and drinking and some murders.

But to understand this label of utopia is to view it in the context of the African American residents' experience.

Buxton was started a mere 35 years after the end of slavery. Numerous African Americans interviewed stated that their parents or grandparents had been slaves, repeatedly sharing stories of their life of slavery. And those who had not been slaves still experienced extreme racism.

They came from that to Buxton—a place where they could go anywhere they wanted, live any way they wanted, eat or shop where they wanted, and have the freedom they wanted.

The freedom to live.

The freedom to be.

The freedom to choose.

That must have felt like utopia.

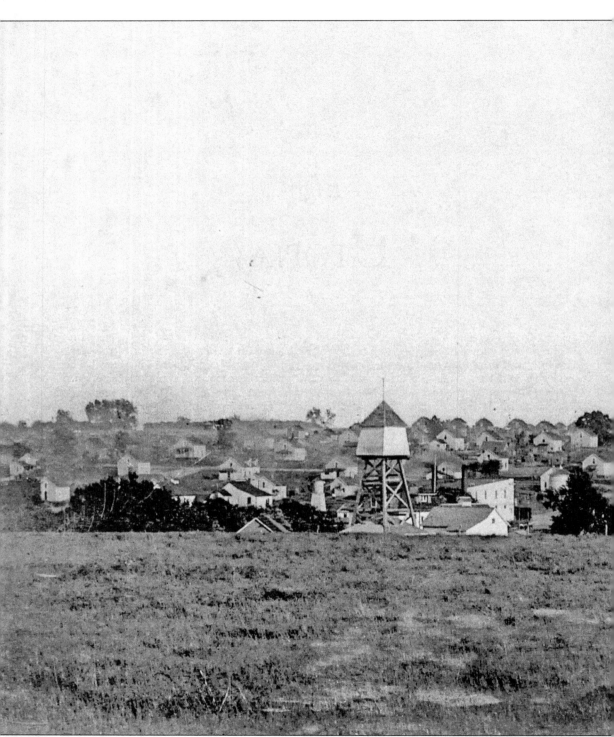

PANORAMIC IMAGE OF BUXTON. "Here one can study the race from a viewpoint that no other large community offers to the Negro. Here he has absolute freedom to everything that any other

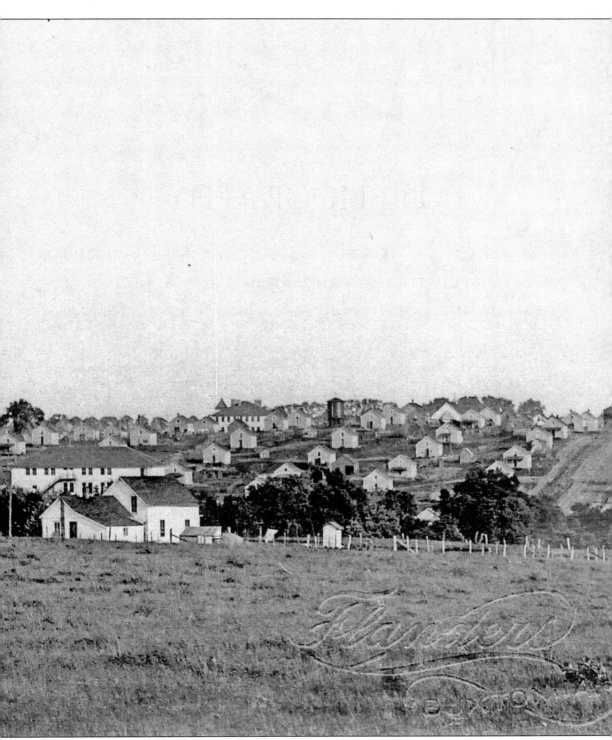

citizen has." (Quote from the *Iowa State Bystander*, October 29, 1909; photograph courtesy Michael W. Lemberger.)

BIBLIOGRAPHY

Beran, Janice A. "Diamonds in Iowa: Blacks, Buxton, and Baseball." *The Journal of Negro History*, Vol. 75 (Summer-Fall 1990): 81–95.

Dickey, LeeAnn, LeAnn Lemberger, and Michael W. Lemberger. *Buxton Roots*. Ottumwa, IA: PBL Limited, 2009.

Gradwohl, David M. and Nancy M. Osborn. *Exploring Buried Buxton: Archaeology of an Abandoned Iowa Coal Mining Town with a Large Black Population*. Iowa City, IA: University of Iowa Press, 1984.

Iowa State Bystander, 1900–1920

Oral Histories of Buxton Residents, conducted by Dorothy Schwieder, Elmer Schwieder, and Joseph Hraba, 1980–1982, State Historical Society of Iowa–Des Moines.

Rye, Stephen H. "Buxton: Black Metropolis of Iowa." *The Annals of Iowa*, Vol. 41 (1972): 939–957.

Schwieder, Dorothy, Joseph Hraba, and Elmer Schwieder. *Buxton: A Black Utopia in the Heartland*. Iowa City, IA: University of Iowa Press, 2003.

Schwieder, Dorothy, Elmer Schwieder, and Joseph Hraba. *Final Report of the Archival and Oral History Phases of the Buxton, Iowa Project, Phase 1*. 1982.

Shiffer, Beverly. "The Story of Buxton." *The Annals of Iowa*, Vol. 37, No. 5 (Summer 1964).

Silag, Bill, ed., Susan Koch-Bridgford, ed., and Hal Chase, ed. *Outside In: African American History in Iowa, 1838–2000*. Des Moines, IA: State Historical Society of Iowa, 2001.

INDEX

Visit us at
arcadiapublishing.com

Printed in the USA
CPSIA information can be obtained
at www.ICGtesting.com
LVHW051618280923
759259LV00037B/242

9 781540 214232